#DOSOMETHINGFORNOTHING

When you're on the fringes of society,
being recognised can mean everything.

In 2015, while working at a London hair salon,
Joshua Coombes took to the streets with his scissors to
offer haircuts to people sleeping rough in the capital
and began posting transformative images on social
media to amplify their voices. These stories resonated
and thousands of people got involved in their own way.
From this, **#DoSomethingForNothing** was born—a
movement that encourages people to contribute their
skills and time to those who need it.

This book explores themes of love, acceptance,
shame and perseverance, while inviting us to see
ourselves in one another and challenge the negative
stigmas surrounding homelessness.

Through the simple act of a haircut, Joshua takes you
on a journey into the lives of people experiencing
homelessness in different cities across the world.

'Joshua's stories show the power that empathy and compassion can have to turn a common, everyday act into something potentially transformative.' **Michael Sheen, actor**

'Hope, optimism, kind curiosity, and real human connection. This book will make you want to do something, just because you can.' **Emma Gannon, author of *The Multi-Hyphen Method***

'This is a moving and inspiring book about how we can be better people.' **Johann Hari, author of *Lost Connections* and *Chasing the Scream: The First and Last Days of the War on Drugs***

Do Something for Nothing

SEEING BENEATH THE SURFACE OF HOMELESSNESS,
THROUGH THE SIMPLE ACT OF A HAIRCUT

JOSHUA COOMBES

murdoch books
Sydney | London

Published simultaneously in 2021 by Murdoch Books, an imprint of Allen & Unwin
and Akashic Books, USA

Murdoch Books Australia
83 Alexander Street
Crows Nest NSW 2065
Phone: +61 (0) 2 8425 0100
murdochbooks.com.au
info@murdochbooks.com.au

Murdoch Books UK
Ormond House
26–27 Boswell Street
London WC1N 3JZ
Phone: +44 (0) 20 8785 5995
murdochbooks.co.uk
info@murdochbooks.co.uk

For corporate orders & custom publishing, contact our business development team
at salesenquiries@murdochbooks.com.au

Publisher: Kelly Doust
Cover design: Trisha Garner
Handwriting artwork: Jamie Morrison
Photographs in the New York section: Valérie Jardin
Photographs on pages 167 and 169: Irene Conesa González
All other photographs by Joshua Coombes

ISBN 978 1 76052 425 8 Australia
ISBN 978 1 91163 216 0 UK

A catalogue record for this book
is available from the National
NATIONAL
LIBRARY
OF AUSTRALIA
Library of Australia

A catalogue record for this book is available from the British Library

Printed by C & C Offset Printing Co. Ltd., China

10 9 8 7 6 5 4 3 2 1

MIX
Paper from
responsible sources
FSC
www.fsc.org FSC® C008047

The paper in this book is FSC® certified.
FSC® promotes environmentally responsible,
socially beneficial and economically viable
management of the world's forests.

To Cedric. You live on in these pages, mon pote.

CONTENTS

INTRODUCTION

IDIDN'T KNOW WHAT I WANTED TO BE WHEN I GREW UP. There wasn't a subject in school that grabbed my attention, or anything in particular that I felt confident in. I had trouble concentrating in class and that was reflected in my behaviour. My teachers saw a kid who distracted his classmates and had little will to learn. They marked my cards from the start, and I don't blame them. I didn't know my strengths then, or the multitude of heartwarming experiences waiting beyond my abysmal grades and the walls of my worn-out school building in the small British town I grew up in. I could only see the things I was not.

I was lucky though—I had a family that allowed me to be myself. My mum bought me a guitar and my aunt gave me her old record collection and I didn't look back. Music was the adrenaline shot I needed to see some kind of future, and I found a community that felt the same way. Punk rock provided me with an education and friends who are still by my side to this day. It gave me a voice and taught me how to put my arm around people who may look and seem different from me.

I'd be lying if I said I had a burning passion to become a hairdresser, or some great love for the craft before walking into a salon in my mid-twenties and asking for a chance. The truth is, I'd stopped touring with bands and had enough of bar jobs. It felt like something I might be good at. I played guitar pretty well, how difficult could cutting hair be? I was naive. The experience humbled me completely. Once I'd quit worrying that I'd destroy someone's self-esteem with one wrong snip of my scissors, I found confidence and quickly realised that the role I played for my clients went far beyond improving their appearance. It was personal and supportive in a way I hadn't anticipated. I learned how to talk less and listen more.

One evening in the spring of 2015, I was on my way to a friend's house after work. I didn't make it. I walked past a man who was homeless at the time. I would often stop to speak with him, either buying him something to drink or handing out some pocket change, but this time was different. While talking, I remembered that I had my tools in my backpack and asked if he'd like his hair cut. In the hour that followed, he told me his story. We connected and became close afterward. The next time we met, he introduced me to some of his friends. Before long I was heading out whenever I could, giving haircuts throughout the streets of London.

The grit and grime of the footpaths felt worlds away from the shiny mirrors and lattes of salons, and I liked it. There was a depth of conversation among the bustle of the city that was rarely found in a salon environment. Don't get me wrong, I never bought into the "So where are you going for the holidays?" chitchat, but it's difficult to share the darkest parts of your soul when others are getting their hair done on either side of you. The streets provide the background noise required to talk on another level, and the time to allow these moments to flow. I wasn't waiting for my next client to turn up. There was no money exchanged, only time.

These interactions introduced me to people from all walks of life, who completely dismantled my perception of homelessness. I began writing about these experiences and taking photos—before and after the haircut. With consent, I shared their words and images online, in an attempt to dissolve some of the stigmas that surround this issue. I came up with a hashtag, #DoSomethingForNothing, to sign off each post, in the hope that other people might join me in their own way.

In the months that followed, my platform grew, and I was managing an inbox full of messages from people who wanted to get involved—either with direct skills, or by pledging to spend time with somebody they wouldn't usually come in contact with. A movement sparked. I left my job at the end of 2015 and haven't been paid for a haircut since. I didn't know what my next steps would be at the time. I wasn't sitting on a trust fund or any savings. I worked part-time jobs at first, allowing me to spend more time on the streets, cutting hair and meeting new people.

I was interested in seeing what homelessness looked like beyond the UK. The ethos from the beginning was to look out for those closest to us, the people we walk by each day without a second thought. However,

I had the opportunity to take this message further. Before long I began receiving emails from event organisers and schools asking me to give talks, and from NGOs and brands wanting to collaborate on projects. This took me across Europe, the Americas, India and Australia. I also travelled to places where I had friends, or friends of friends, with a spare bed or sofa. Wherever I went, I'd pack my hair tools and get out to talk to people. Of course, the simple act of a haircut isn't going to solve anyone's problems, nor make a dent in the vast numbers of people who sleep on the streets of our cities each night. It has, however, become a great vehicle for me to listen.

This book isn't about homelessness; it's about humans and showing up for one another where we can. I'm thankful for each person within these pages, for the time we shared together and for agreeing to be part of this. These conversations are a collection of audio and video recordings that will now live on in this text. Thank you for reading and for seeing people who can so often be invisible.

London

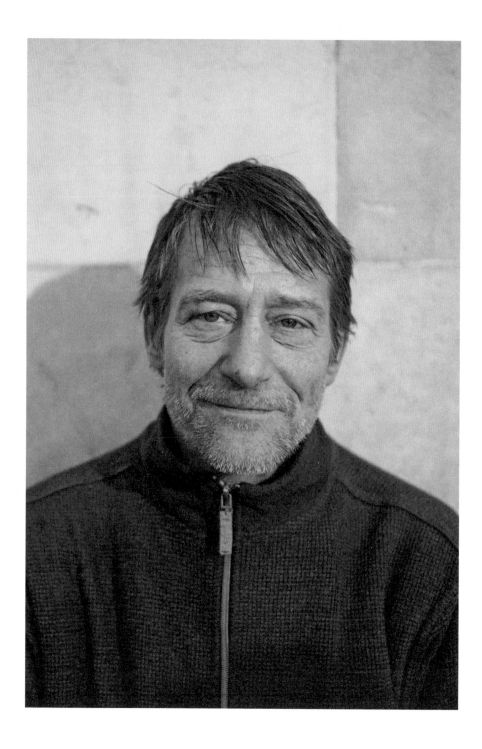

David

IT WAS SUMMER 2018. The city was in a good mood and it rubbed off on me. I took a turn off Borough High Street toward the south entrance of London Bridge station. Hundreds of people scurried around, shadowed by ninety-five stories of the Shard building, the tallest structure in London's skyline. As I looked ahead of me, I saw a man sitting cross-legged on the ground, nodding and saying hello to just about everyone.

"Afternoon, sir! Afternoon, madam!" he called out. "Afternoon, sir! Beautiful day today, isn't it?"

I greeted him as I approached. "All right, mate. How are you?"

He spun around in my direction. "Hello, fella," he said with a broad grin. "I'm good, thanks. How about you?"

"Great, thanks."

"I'm David, good to meet you."

I kneeled down on the pavement next to David while London carried on at the same pace. Platform announcements from the tannoy at the train station echoed from a distance and distorted with the sound of the busy streets. I noticed David's holdall bag behind him, bulging at the seams with his belongings. At that moment, he was greeted by a lady walking by: "Hi, David! How are you today?"

"Afternoon, madam! I'm really well, thank you! You have yourself a good day now."

The same thing happened a minute later. It was clear this was David's regular spot.

"Some people call me the 'good morning man'"—David chuckled—"because I'm outside the station at five forty-five in the morning most days, right there at that entrance. I'll sit there and say good morning to *everyone* I see, and you know what? I think it really means something to

people. It's that little moment in your day where somebody acknowledges you."

I wanted to keep talking. I told David that I had my barber tools in my bag and asked him if he'd like a haircut.

"Ah, you know, I'd love that. I've been waiting for ages to get my hair done! But hang on, where are we gonna do it? Right here?"

"Yes, exactly," I replied. "Let me run to a café and see if I can borrow a chair for you to sit on."

"Oh, don't worry about that, I have some things here." David sprang up eagerly, then took a few pieces of cardboard from beneath his holdall and folded them into a square to sit on.

It was obvious that David was sleeping rough. He scrubbed up well, but the telltale signs were there: the deep bags under his eyes and the chapped edges of his hands; the timeworn marks on his pants and shoes.

I shook off a black nylon gown and draped it over him. "So, what keeps you going out here, David?"

"Hmmm . . ." He paused for a second. "It's the good and the bad in people. The conversations. I do see some really nice people. I also see people who are hurting, and they don't know what to do with themselves. They'll sit down and talk with someone like me and I know it does help them a bit. Maybe it's because they've found someone who's a little bit worse off than they are . . . I dunno. I'm definitely more of an agony aunt than a homeless person sometimes."

I switched off the clippers for a moment. The loud buzzing of the motor inside stopped.

David looked me in the eye and continued introspectively: "It's still surreal for me. There's no way I would have seen myself sitting here . . . no way at all. I've realised how we trick ourselves into believing that we're in total control of our lives, and we're really not. There's so much that can happen to a person that you ain't got no say, or no control over. It's frightening . . . it's really frightening. I see people walk past me and I get the odd person with a look of disgust on their face, but mostly I see fear on their faces, because they don't know how you got here, and they're scared that they could be here also."

Every so often, people would stop and speak with us to see what was happening.

"You're giving him a haircut!" a lady said. "Is this what you do . . . ?" When it feels right, I try to divert these conversations in the direction of the person whose hair I'm cutting at the time. I'd prefer the passerby to hear more about their life than mine.

"Well, David and I met this afternoon," I explained. "This is your spot, David, isn't that right?"

"Yeah, that's right," David responded as I carried on cutting. "I'm always here, or just over the road by the station."

"So, you two didn't know each other before today?" the lady inquired.

"Actually, no, we didn't!" David laughed. "We're doing pretty well though, I think . . ."

This kind of thing happened a few more times as the afternoon went on. I noticed other looks, however, the ones David had mentioned. Looks of disgust accompanied by a shake of the head. When David called out to say hello to some people, they seemed almost scared to make eye contact. I was interested in his perspective on this.

"A few nights ago, I was proving a point to a young lady who sat down with me. I said, 'Watch this.' I asked a few people who walked past, 'Excuse me, have you got the time, please?' but there was no response. I'm polite. I was brought up with good manners. I don't see no reason to not be that way. And you know? It took about thirty people before one woman turned around and said, 'I ain't got no change.' I said, 'No, madam, could you tell me the time, please?' She said, 'Oh, of course . . . I'm sorry.' But the majority of them people turned around without thinking, which can get really frustrating, ya know? I think people forget that I had a life before this moment . . . but it's easy to do."

David's emotional durability was admirable. To somehow remain empathetic to those who looked down on him for no just reason.

"Honestly, before this happened, if someone had said to me, 'In a year's time, you're going to be begging on the street for your food and money,' I would have been really insulted—like, that's the biggest pile of crap you've ever spoke. Then suddenly, it all changes. It's easy to get to this place, but it's damn hard to get out of it . . ."

I was using the trimmers to do some final touches before finishing David's hair. Part of me was intrigued to know more about his life before becoming homeless, but I had a feeling we'd meet again. I handed him the mirror.

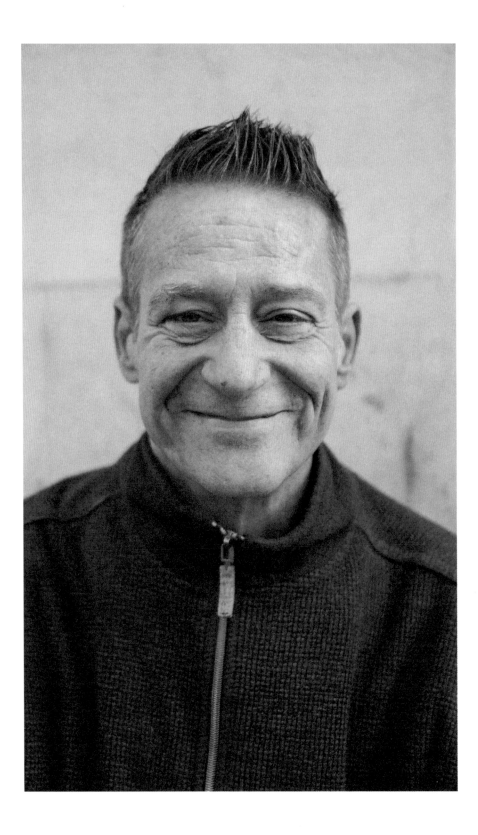

"Ah, nice one, fella. I love it! I never usually style the fringe up like this." David laughed as he stroked the front of his hair. "But I really like it!" He kept looking at himself for a while, turning his head from one side to the other. "You've knocked some years off me today, you have."

We said our goodbyes, and I told him I'd come by and see him again soon.

A few weeks later, I was back at London Bridge to see David.

"Good to see you, fella!" David exclaimed. "My haircut still looks pretty good, doesn't it?" He twisted back and forth on the spot, modelling it for me with a smile. We grabbed something to drink and headed to a bench nearby, close to Guy's Hospital.

"I was born there," David said, "inside those walls. Funny to think about it now. Nearly fifty years ago my mum had me right there in that building, and now here I am . . . At first, I felt humiliated, sitting out here. I felt ashamed, ya know? You don't go through life thinking you'll end up in this position. I had my own business going. I employed six people and myself. Things were going well, but when something bad happens in your life, things can fall apart."

David went on to tell me about a day that changed his trajectory completely. One night, while driving on the motorway with his family, including one of the youngest members, David had an accident at high speed. As you can imagine, everything happened very quickly. One of them didn't make it. This consumed him thereafter, and he became estranged until he was unrecognisable to them and himself. Things spiralled from there.

It was a few months before I'd next see David. There was a tiredness that wasn't present before. His eyes were red and glazed. He looked exhausted. It was raining and the streets were soaking wet, but David sat in his usual spot with his hood up. We took shelter in a walkway around the corner.

"It's good to see you, Josh. Bloody hell, my barnet looks terrible, doesn't it?!" David laughed as he brushed his hands through his hair. "You don't happen to have your stuff with you, do you?"

The wind was blowing strong that day, so I stretched the gown tightly around David and tucked the edges underneath his feet to keep it from moving, before setting up my clippers.

"So, what's the latest?" I asked.

"I haven't been too good lately, to be honest. This week, I've had a couple of days away from my spot because I had some seizures. I have epilepsy, ya know?"

David hadn't mentioned this to me before.

"It hasn't hit me for a while, then on Monday—*boom!*—I had two seizures. I was lying on the street and ended up waking up in the hospital, thinking to myself, *What the hell am I doing here?* That happened on Monday, last week. I was back at my spot by Thursday. I hadn't been there for two days, and it was so good for my heart when I came back. The amount of people that came up to me and said, 'David, where have you been?' or, 'David, are you okay? We missed you.' It's a real buzz to think that anyone actually cares . . . I try to be happy, most of the time because everyone is so sad . . . They're up early, on their way to work, it's understandable. One time, this man who always sees me stopped and said, 'You know what, David? You're the only person who says good morning to me in London.' At first, when people say things like that, I thought it was just banter, but it's not. People really look forward to seeing me."

The relationships David had built with those who passed him each day was quite evident. I saw it every time we were together. I know that these small interactions are genuinely what kept David smiling each day, and I was happy they had been validated for him in some way. Despite recent events, somehow David's flame of positivity had not been snuffed. He seemed as bright as ever, but his energy wasn't quite as effortless as the first time we'd met. A few years of living out in the elements can tear the immune system apart. *Here today, gone tomorrow* takes on a whole new meaning when you're staring down the barrel at another long winter on the streets. We made a pact of sorts on that day, a verbal agreement that this would be the last year that he'd spend outside. There was no clear plan, but we set an intention.

The rain stopped as I finished his hair.

"I'm ready for a new start now. It sounds a bit silly . . . but, in a small way, a part of me is glad because being out here has shown me a different part of life. It's opened up a different part inside me. I've got a lot more feeling, a lot more love, a lot more everything."

* * *

In the months that followed, I'd see David when I could, keeping his hair tidy when he needed a trim. Other times we'd just meet up and chat.

Now, as I'm writing this in the spring of 2020, the world has been clutched by the coronavirus and the tragedy that's come along with it. The pandemic has brought people together in many ways, yet it certainly doesn't treat everyone equally. Those in already challenging circumstances are no doubt in a more vulnerable position. Currently, there are far fewer commuters, or tourists to offer money to those sleeping rough in the capital.

I telephoned David when the coronavirus hit the UK to see how he was doing, and thankfully, in such uncertain and challenging times, this call was a breath of fresh air.

"Hello, mate, how you doing?" David answered with a joyful tone.

"I'm good," I replied. "Just checking in to see how you're holding up."

"Actually, I'm really good as it goes. You won't believe it, but I've just got myself a room! Down Walworth Road. Proper accommodation . . . I should be able to register with the council now and all that. It's brilliant news, Josh. Absolutely brilliant, mate. Now I have an address and everything, it all changes."

"I'm so happy for you, mate."

"Bless you, my man. I'm really happy too."

"Do you remember when we made that pact?"

"Yeah, I remember! That's absolutely right, brother. Okay, I'm gonna love you and leave you. I gotta go and do some cooking now, but I'll talk to you very soon."

If circumstances were different, I would have headed straight over to David's new place to congratulate him, but I'm looking forward to the moment when we can see one another again. I hope this is a new beginning for David. A chance for him to take the waves of positive energy he provided so many Londoners and speak kindly to himself.

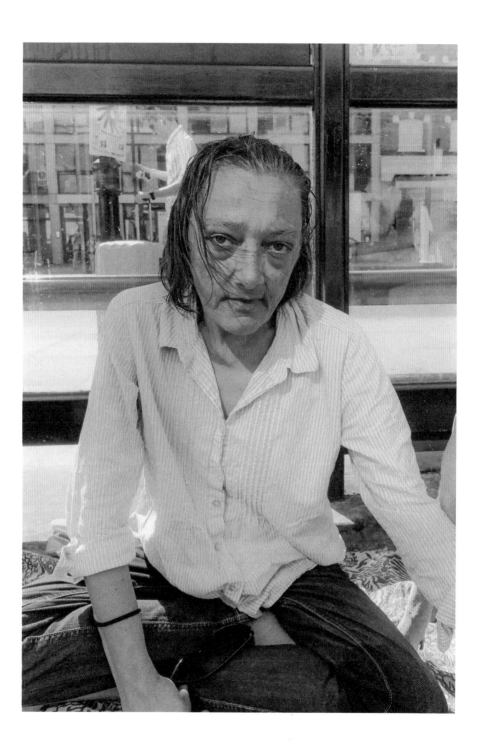

Emma

I WAS ON THE TOP DECK OF THE NUMBER 21 BUS going through East London when I saw Emma sitting cross-legged in the shade, adjacent to the bus stop, with her belongings spread out around her. When I got off and greeted her, I was met with two pairs of brown eyes.

"Hello . . . I'm Emma, and this is Lashes." She put her hand on the head of the dog lying on the concrete next to her. "She's my baby girl. I've had her since she was just a puppy."

Lashes stretched her front legs before waddling over to me.

"Aww, she likes you." Emma smiled. "Lashes is great with most people, but she can sense bad energy. She tries to protect me, bless her. Not that she could do much harm to anyone." Emma's voice was soft and husky and cracked slightly as she spoke. At the end of each sentence, she'd take a small, sharp breath as if to summon the energy for her next words.

I asked how her day was going and if she was sleeping on the street at that time.

"Yes, I am. It's been three months now. It's a struggle for me to get a night inside, because it's hard to find a hostel that allows pets and there's no way I'm giving her up." Emma peered at Lashes lovingly and paused. "If someone had told me a year ago that I'd be homeless, I would have said, 'Are you joking with me? Never.' I wouldn't have believed them. But, saying that, I don't think anyone could imagine this happening to them, not really. Could you?"

I took my backpack off and sat down.

"I lost my husband to cancer last year . . . his name was Kenan. We were together for twenty-eight years. I go through stages of being able to talk about it and sometimes I just cry my eyes out, you know?" Emma looked down the street into the distance, and then to the ground. "I lost

my partner, my backbone, my best friend. I haven't been doing too well, to be honest . . ."

"How did you and Kenan meet one another?"

"His parents came to London from Turkey when he was young. They opened up a shop here and he started working with them. That's where we met. We began seeing more and more of each other and . . ." A smile crept onto Emma's face. "Well . . . we got to know each other."

A young man stopped and handed Emma a sandwich and something to drink. We all chatted together for a minute. When he left, it felt like a good time to offer her a haircut.

"Really? Is that what you do? We haven't got a hair dryer out here, but that doesn't matter, does it? Once I get inside a hostel, I'll wash it and use one there. I'd love that. I've lost so much weight recently, so that will make me feel a little more confident, you know?"

I started unpacking my bag and Lashes was interested in everything. Her eyes followed each item until I placed it down. She gave it all a sniff of approval before I could get started. I put a cape around Emma's shoulders and began brushing her hair.

"We were living in Hampstead for a long time—me and Kenan— over on Grafton Road, right next to Kentish Town City Farm. I volunteered at the farm when I could. It was my little break from the world. I used to love spending time with the animals and seeing the smiles of the children who came in. There's nothing better when you're a kid, is there? Being up close to animals for the first time is so exciting. We didn't have any problems with the house when Kenan was alive. We managed rent all right and supported ourselves for the most part. Everything was ticking along, you know? When Kenan died, it nearly killed me too. I'm not sure how I'm coping now . . . Anyway, our landlord changed a few months later, and that's when things got worse. One day, he telephoned me to say that the neighbours were complaining about noise from Lashes. It was strange, because she doesn't bark all that much and nobody had mentioned it before. Thinking back, he was probably looking for any excuse he could to get me out. I received a letter a few weeks later saying that the rent was going up. Then he telephoned me again telling me there had been more complaints. I pretended that I'd taken her somewhere else, which worked for a couple of weeks, but then he put a camera up near the

entrance of the block. It wasn't long before he found out and that was that."

I wasn't sure how long we'd been speaking. Every few minutes a bus would stop, submerging us in a small wave of its passengers before calm resumed. It was one of the hottest days of the year and Lashes was panting heavily. Emma reached into her woven bag and pulled out a small plastic tub to pour some water for her dog.

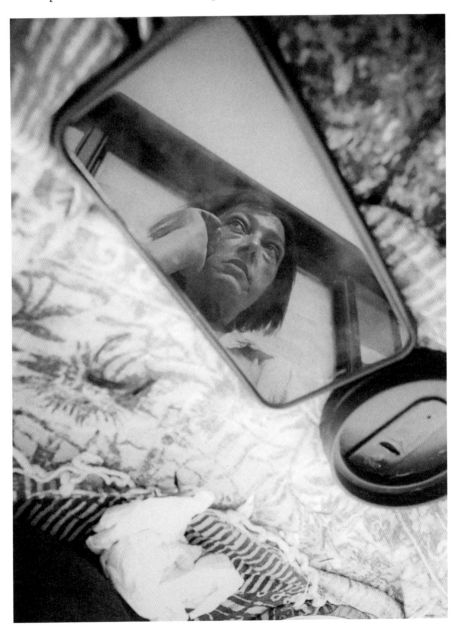

"My mum lived near Essex Road, in Islington. That's where I grew up. We were really close, me and Mum. I sit here and think, *If she was here today, there's no way I'd be homeless now.* She just wouldn't have allowed it. My dad is still alive, but he's lived abroad for years, in Spain. He doesn't know what I'm going through at the moment, and it wouldn't help even if he did. He is in his eighties and has money problems of his own. It would just add to the stress. And what can he really do from over there?"

Emma shared her heart, which left her visibly emotional at times. I couldn't help but wonder if there was anybody else for her to lean on; I thought of the stress of not having an outlet for these emotions. I know how messy my own life gets when I keep things locked up. I've learned that the hard way at times.

Emma continued: "Although sometimes I feel like saying, *Forget this life, just end it*, I don't have the guts to do that, and I feel like that's basically the same as saying, *Don't do it*. Because, all I need is a place or a room and I'll be happy. I could go in, close my door, and be back to normal life, doing normal things: waking up, having a coffee, taking the dog for a walk, coming home, doing some housework. I was doing embroidery before and getting really into gardening."

There was a sense of optimism in Emma's words as she walked me through her hypothetical daily routine and the things she had once enjoyed. I was growing increasingly fond of her.

"I know that I'm a good person and that my heart is good. I've had some bad things happen to me, but I know I'm good inside. I'm not really a God person, but I do believe that there is something, somewhere. Because, although I'm having a bad life right now, I do get good people who come along and help me. I'll get there. I've got to. Nobody is going to do it for me."

I went to pass Emma the mirror, but she told me to hold on a moment.

"Let me just grab my lipstick . . ." She sifted through her bag until she found it, along with a small pocket mirror. I watched as Emma applied some bright-pink lipstick and pouted in her reflection, moving her face from side to side. It made me smile. When she was ready, I handed her my larger mirror. She looked at her hair.

"Thank you so much for this. You know what? You've really made me feel good. Bless you, you're a gentleman . . . Don't I look fab?"

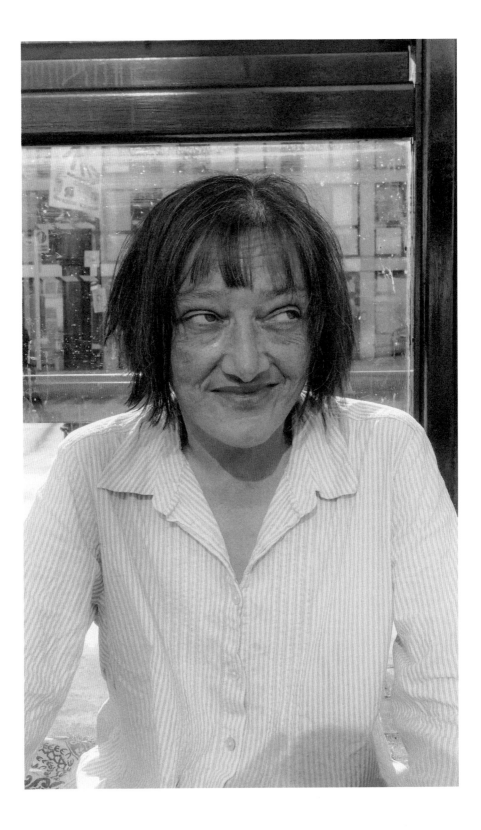

Alex

I WAS SPENDING A LOT OF TIME IN EAST LONDON and would see Alex sitting outside of a small supermarket on Old Street. I stopped to talk with him one summer day and learned more about his situation. He'd moved to the UK from Romania a few years prior and was doing okay for the first twelve months; a friend helped him find work in the city.

"I worked any jobs that I could when I came to London. I enjoy working. I was happy to be here and for a new start. Things were not so good for me in Romania. Opportunities were limited. I didn't have any support."

London was humid and sticky that day. The fumes of passing traffic curdled invisibly in the air. It looked as if it had been some time since Alex had had the chance to get himself cleaned up. We spoke for a while longer before I offered him a haircut.

"Really? Hmm . . . but where would I have to go?" he replied hesitantly.

"I carry all my things with me." I slid off my backpack and placed it on the ground next to us. I unzipped it to show him the clippers and scissors inside.

Alex opened his eyes wide and laughed. "Ha! I don't believe it, that's crazy." He looked around at the street and the passersby. "But I think here is too busy, no?"

Old Street was noisy, as it always is, so we walked for a few minutes until we reached a small alleyway. There was a guy sitting at the far end on a cigarette break, but he was glued to his phone and barely noticed us. Alex sat on a small curb and got comfortable while I set up my things. His light-brown hair was greasy, so I used some dry shampoo and brushed it through.

"I don't mind what you do with my hair," Alex said. "Just make me look clean and I'll be happy."

I was glad we'd moved away from his spot. Alex's demeanour had changed; a new person emerged away from the eyes of the public.

"It can be hard sometimes when you see the people walk past you on the street, looking like robots." Alex moved his arms mechanically with a deadpan look on his face, expressing himself in frustrated, broken English. "I cannot tell nothing to change their opinion about me . . . You cannot judge one person about his appearance. You need to first listen to him and see the way he thinks, the way he acts, the way he behaves—*then* you can judge a person. Everybody's life is different. Things were okay for me when I first came here, but I couldn't see the future . . ."

He started talking about his most recent job in London before becoming homeless: "I was working close to here, a car wash. I could see that workers were not treated well, but it was fine for a little while. Then there were some weeks when they would not pay people on time. Lots of people like this. The bosses are the only ones who are winning in this place. They take people who need quick work and pay them low. This was my situation, and I had enough of it. I got in an argument one day and I left."

The distant roar of London filtered through into that back street. Car horns blended with the loud hum of a ventilation fan spinning a few metres away from us.

"I don't have many friends here . . . I met this woman recently and I've been staying at her house sometimes. We are sort of together but not together all of the time. I cannot stay there always. It wouldn't be right."

I was curious to know if Alex had thought about travelling back to Romania now that things had taken a turn here. I knew it wouldn't be easy, but I was interested all the same.

"There's not much for me in Romania. I still know some people, but not much family. I lost my mother ten years ago—and my father, he died when I was young. If I go back to Romania, I won't be going back to any kind of home, so I have to make it work here now."

Alex was clearly determined to fight through this period and realise his dream of a new life in London. I figured he'd made a promise to himself and wasn't going to break it easily. I've heard countless stories of people in similar positions, who travel to the UK from pretty impossible situations with hopes of a new start. For all the opportunity it has to offer, maintaining even a humble existence in the capital can suck you dry financially.

Workers' rights are zilch and there's always somebody behind you to step in if you're not up to it.

Alex's hair fell to the ground, covering the thickly painted double yellow lines on the road before us. I'd taken off a lot of hair and shaved his face clean. I rubbed some styling cream into my hands and ran them through his hair.

"Nice, nice! Wow, look, no beard!" Alex brought one hand up to his face and stroked his chin while the other held my mirror. "Yeah, this is much better."

I took a photo on my camera and passed it to him to have a look.

"Wow! Fucking hell, man, I look so different!"

We headed back to Old Street. Alex didn't have a phone, so I said goodbye hoping we'd bump into one another again sooner or later.

It turned out to be later, almost two years later. I was in Hoxton, East London, helping my friend Hal Samples set up a gallery space for a screening of his film *Samples of Society* that evening. Hal has been a mentor of mine over the years and a real brother. Through multimedia projects, he's made it his mission to make people experiencing homelessness visible. As I was hanging up a sign in the front window, I saw someone walk by with their hood up. Somehow, though I could barely see his face, I knew it was Alex. I stepped outside and called his name. He stopped and turned around, squinting until it clicked.

"Hey! Joshua! How are you?"

It was good to see him again. We hugged and stood there talking. I asked him how he was doing.

"Hmm . . . things are still difficult. I'm staying at my friend's place at the moment, near here."

I asked if we could meet up later that week.

"Yes, for sure," Alex said. "Take my phone number."

I called him a few days later and we met on Old Street again. We set up right there on the pavement this time, in the hope that people might drop some money as they passed. Alex's hair and beard were long and shaggy and he'd clearly lost weight.

"When was the last time you had your hair cut, mate?" I asked. "It can't have been when I did it last."

"No!" He laughed. "I did it myself six months ago with some clippers, but I did a terrible job, I think . . . I'm still out on the streets when I'm not at my friend's place, so things are pretty much the same . . . I can't get much help or financial support here. I'm tired now. I've decided to try and leave soon. I'm having problems with my documents. I don't know what I'll do."

I've tried Alex's number a few times since then and it always goes straight to voice mail. I worry that restarting in Romania could be just as difficult as his time here in London. I hope things have worked out for him.

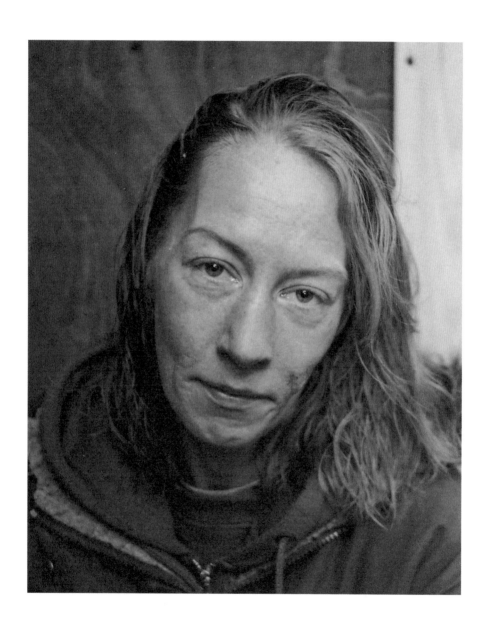

Lavane

IT WAS A RAINY EVENING IN NOVEMBER 2019. I had just dropped off my phone to be fixed in central London and had an hour to spare. I walked down the Strand, a busy thoroughfare stretching roughly a mile east of Trafalgar Square. It's impossible to miss the presence of homelessness in this area. Located nearby are some of the larger organisations that provide services, drawing hundreds to their doors on a daily basis. There is also Charing Cross train station, with its underground labyrinth of corridors and walkways, an obvious go-to for those needing shelter from the elements. I've met countless people here in recent years. There was a time when I'd visit almost weekly to give haircuts, with plenty of willing clients.

This time I had no agenda. Despite the miserable weather, it was nice to be walking around with an hour to myself. As I crossed the road, I spotted a figure silhouetted by the light of a shop window. Moving closer, I saw it was a lady with a fluffy white dog nestled in her lap. She looked familiar. When I introduced myself, she said her name was Lavane, which jolted a memory I couldn't grasp at first. Our conversation then led us to a mutual moment of realisation.

"Sometimes I cut hair around here," I said. "It's been a little while, but—"

"Hang on, did you say your name is Josh?" Lavane interjected.

"Yes."

"Did you ever cut hair for someone called Nick?"

I couldn't forget Nick. He was homeless too, and spent his days on the Strand with his dog, Scarper, always at his side. We'd often chat when I was passing through, and one day I cut his hair.

"Well, you should probably ask my girlfriend," Nick joked, laughing loudly enough to wake up Scarper. "I'm happy to take my beard off, but the thing is, she likes it. So maybe we could leave just a little bit, yeah? Then I'll tell her it's your fault if it doesn't look good!" He flashed a mischievous grin.

Nick spoke freely about his life—working as a landscape gardener, to serving time in prison, and how living on the street, through its struggles, had taught him how to love.

"I wasn't in prison for a long time, but things felt different afterwards. I had to work at rebuilding it all from scratch. Maybe I didn't work hard enough. I didn't plan on living on the streets, and it's not easy, but I'm used to it. I know how to do it. I'm thankful, because I met the love of my life out here. Lavane is the best thing that ever happened to me."

That was in May 2018. I saw Nick one more time later that year. Then, in March 2019, I was sitting on the train scrolling through some news items on my phone, when a headline grabbed my attention: "Homeless Man's Beloved Dog Refused to Leave Owner's Side for 12 Hours after He Died in London Street."

Scarper had waited with Nick until he was discovered by the police in an underpass near the Old Kent Road. Nick had gone for a walk the day before, leaving his belongings on the Strand, and never came back.

I didn't get the chance to meet Lavane when Nick was alive, but now I knew exactly who she was.

"Yes, I gave Nick a haircut. Just over the road there." I pointed across the street from where Lavane and I were sitting.

"I know who you are!" Lavane said excitedly. "Nick used to talk about you. In fact, he would wind me up, saying, 'I'll get my friend Josh to shave my beard off. You won't like that.' You were the 'evil barber' to me," she joked.

"And I know who you are. I'm so happy to meet you, Lavane."

As we sat there talking, she told me about a short documentary project she was involved in. She had recently been asked to make a film on an iPhone about her life on the streets.

The day before the screening, she asked me if I could cut her hair, to make her feel "a bit more human" for the event. We set up against some

scaffolding on the building next to her spot. As the London traffic flew past, I sprayed her hair wet and brushed it through. Lavane and I had a chance to go deeper that day. She'd been through a lot.

"I think in general, people feel more sorry for a woman than a man. I mean, I am quite vulnerable, but I never show it. I'm one of those people that, when I'm feeling low, I need to lock myself away, but obviously that's difficult out here. There are people who are quite generous, and that helps. I don't like to ask people for money, and I don't want to risk shoplifting. There have been times when I've had to go and wrap up toilet paper to make my own sanitary towel. Even going to the toilet is hard because I have Misty. Most hostels don't allow you in with pets. I've had her since she was just six weeks old. She's everything to me, she's like my child." Lavane looked down at Misty and stroked her stomach. "Aren't you? I don't know what I'd do without her. Before Nick, I was married for ten years and I had a really bad relationship . . . There was a lot of domestic violence. I left after he put me in hospital for the second time. That's when I became homeless. I'd been abused as a child . . . at the hands of my dad. When I was thirteen, I was taken into care, and for years moved from children's homes to foster homes."

Landmines of trauma had been laid in Lavane's path from a young age. Her words reflected the deep sadness in her eyes. I found it difficult not to get angry, thinking how swiftly people like Lavane can be perceived from afar in the fleeting evaluations we make of complete strangers, based solely upon their appearance. In spite of her hardship, Lavane is anything but a victim. Her spirit is what shines, her kind nature that has remained intact through everything. I know that meeting Nick helped her in many ways.

"The last place I thought I'd find real love was on the streets, but then Nick came along. We would sit on opposite sides of the street and catch each other's eyes here and there. Then one day he crossed the road and said to me, 'If you ever need anything, just ask me, yeah?' Scarper and Misty didn't get along too well. Nick would call her a little rat! But he was genuine and kind. He used to go to the shop next to me to top up his Travelcard, but I knew it was really to come by and have a chat. We just developed a relationship. I never met anyone who had loved me that way. He didn't care what people thought of him. He was unashamedly himself.

I loved him for that—even when he smelled bad! He lived his life and had his flaws, like we all do, but his heart was good. He showed me a different way. He showed me how to live on the streets and how not to be frightened. It really gave me back my confidence. I really fell in love."

Lavane showed me a silver band on her finger and spoke about the day she and Nick went to Argos to choose it. It read *I love you* on the inner side.

"Nick died before we had the chance to get married, so I'll be his fiancée forever."

When I was finished, I showed her a photo I'd taken of Nick after I cut his hair, and we shared some memories of him. I know Nick would've been happy that fate brought me and Lavane to eventually meet.

At the time of the film screening, I'd only known Lavane for ten days, but I felt so proud to see her on that stage, answering the audience's questions when the film had finished. She was raw and real and told it like it was.

I arrived back in London from Australia in February 2020, just as the coronavirus was at the doorstep of the UK. When lockdown restrictions and social-distancing rules commenced, I called Lavane to see how she was doing.

"I'm struggling, really. It's been difficult . . . Hardly anyone is out on the street, so I'm not earning any money. Nobody has given me any information. Everyone is just walking past. Nobody wants to talk to you in case you've got it. It's better to be on lockdown, innit? It's hard for me to get any food or anything now. London is a ghost town. I sat out yesterday, down the Strand, just before everything closed—the pubs and restaurants and all that—and I literally made fifty pence. That's what I made all day."

I got off the phone wanting to do whatever I could to help. The UK government had begun its drive to book out hotel rooms for those living on the street, but it wasn't happening fast enough and people were falling through the cracks. While the press conferences at Downing Street celebrated their efforts to help rough sleepers, the reality was a different story. I posted an update about Lavane on my Instagram, in the hope that we could raise some funds to support her. By the end of the day we'd raised some money, which I wired to her directly. It wasn't huge, but enough to

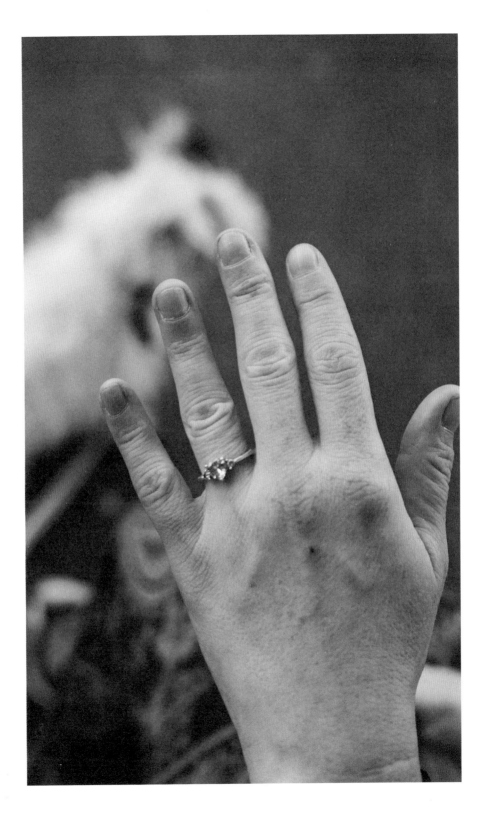

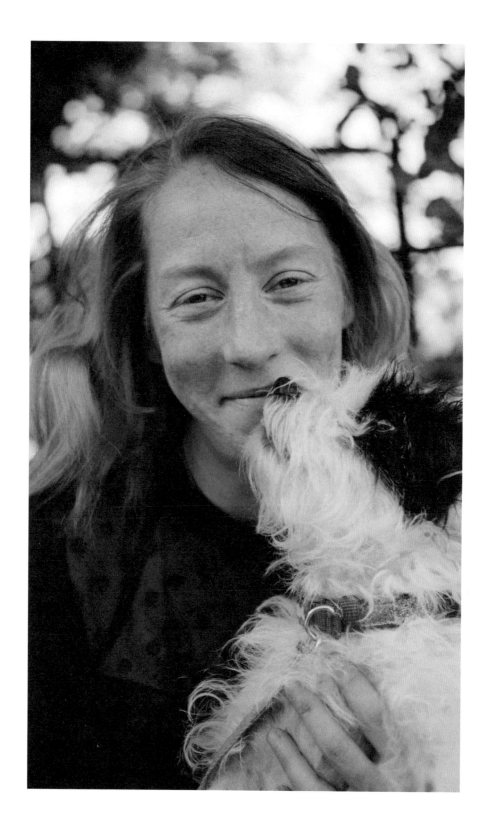

change the tides. She booked a room in a hostel in New Cross, where she could stay with Misty for the next two months.

Now, as I complete this book, Lavane hasn't spent a night on the street for nearly three months. She worked out a deal with the lady who runs the hostel, and feels welcome there. We met for a coffee recently. The colour was back in her cheeks. She had more weight on her body. Her clothes were clean. Things are still uncertain, but a shift has taken place. Lavane spoke about some thoughts she'd been having of what she might like to do in the future, when things calm down.

"I used to work at a special-needs school with children who have learning difficulties. I really enjoyed it. I'd like to go back to that. It's where my heart is. I was an assistant, not a trained teacher, but I think I could do it. AND, I don't have a criminal record . . . Through everything, I'm clean! Can you believe that?" Lavane squeaked with laughter. "I think whatever I do, it has to be with people, with some freedom to be who I am."

I know that Lavane's strength can inspire more people than she realises. I'm proud to call her my friend. In our last conversation, she said she was thinking about writing a book herself. That's a great idea.

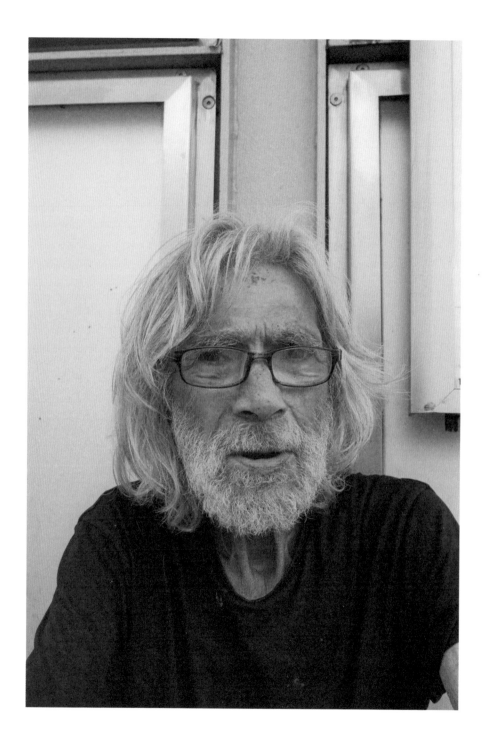

Bob

I FIRST INTRODUCED MYSELF TO BOB NEAR ELEPHANT AND CASTLE, in South London. He was standing outside the front door of a pub, asking for change from passersby. Bob wasn't there to get a drink; he was looking to make enough money to book himself into a hostel that evening. Winter was breathing down the neck of that crisp, bright October day. Bob wasn't all that talkative at first, and I could understand why. He was hustling and I was getting in the way, but we would begin to see each other more often.

Elephant and Castle was on my route to central London, which gave me the chance to stop when I was passing through. One day, I asked him if he'd like his hair cut, but for one reason or another, Bob wasn't ready.

Winter came and went, and I saw Bob here and there, usually shivering while people scurried in and out of the station behind him. I'd buy him a cup of tea and give him some coins when I could, then I was out of town for a while.

I ran into Bob again on my first week back. The skies were overcast, and daytime traffic screeched on the junction surrounding us.

"All right, Bob!" I called out as I got closer. "How are you, mate?"

"Josh! Where have you been? I was hoping you'd come around sooner." He sounded downbeat. "I think I'm ready for that haircut now . . . I mean, look at me." Bob's white hair was shaggy and dirty. "Did you bring your scissors today then?"

"I certainly did, mate. It's time to freshen things up a bit, wouldn't you say?"

"Yes, it is. I turned seventy recently. I need you to take some years off, please!" Bob chuckled. He happened to be sitting in front of a Transport for London tube map, which had the words *MAYOR OF LONDON* printed on the bottom corner, just behind his head.

"Ah, so it looks like you're the mayor of London today then, Bob," I said, gesturing at the map.

He turned around and laughed. "Yeah. It looks like I am!"

"How about you make more of an effort to help people sleeping rough in the city?"

"Yeah . . ." Bob smiled. "That would be about right, wouldn't it? That's the first thing I'll change as mayor . . ."

What a radical idea that would be: to improve, as first priority, the lives of the city's most vulnerable. Politicians talk the good talk about homelessness with new budgets and pledges in the future tense, but those rarely come close to fruition.

I remember reading an article written by the current mayor, Sadiq Khan, in December 2016, months after taking office: "I see this rise in rough sleeping and homelessness—in one of the wealthiest cities in the world—as a growing source of shame. And as Londoners, as a city, and as a country, I believe we have a moral duty to tackle it head-on." Unfortunately, as the months and years have rolled by, the barrel of these words has run dry, and now they're empty. All you have to do is walk around London for a few hours to see that things have gotten worse, not better.

A few of Bob's regulars hurried by, calling out to us on their way past. "Hey, Bob! Are you getting yourself a haircut? Nice one, mate!" and "You're looking sharp, sir!" There are days when London sucks the life out of you. I once heard an American comedian make a joke about British politeness after visiting London, saying, "I dunno who made this shit up, but I'm telling you, it's a lie!" And in many ways, he's right. I've seen the bright-eyed giddiness of tourists wiped away in a flash when bowled over by commuters for not standing on the right side of the escalator, but I've learned a lot about everyday Londoners while spending time with those experiencing homelessness in the city. There's so much warmth beneath the harsh and spiky exterior. People are rushing around like their life depends on it, because in many cases, it does. Missing the bus or train to work can have all kinds of consequences. When you're fired for turning up late, that can be the difference in whether you have enough to pay the rent next month or feed your family. We all need something in our day to distract us from the hamster wheel of stress and worry. I'm always surprised by how loving complete strangers can be, when given the

opportunity to express that.

"So how long have you been homeless, Bob?" I asked.

"Umm . . . It must be five and a half years now. Yeah, that's it, just after Christmas in 2013. That was my first night out on the streets."

"Do you remember that night well?"

"I do . . . It was cold and lonely. I came up this way—Elephant and Castle—not long after it happened, from South Croydon, because I thought there'd be more services to help."

"Is that where you're from, South Croydon?"

"Yeah, well . . . I'm from Purley, just down the road. That's where I met my wife, Meryl. We met at a nightclub there, way back. We were married for nearly thirty years. When she died, it knocked me for six. It was so sudden. I just couldn't get used to it after being together for so long. I couldn't run the house on my own after that."

I had already begun snipping sections of length from Bob's hair.

He went on: "I still have some family. I have two brothers, one older, one younger, but I can't stay with them. My little brother is disabled now. We used to work together, actually, on building sites when we were younger. That's what I did for most of my life, building houses and that. I learned with my dad when I was a teenager. It runs in the family. I enjoyed it, working with my hands like that."

Bob glanced down at his hands that were poking out from either side of the cape I'd wrapped around him. They were cracked and covered in dirt, with small black age spots speckled across them.

"Every house we built was a bit different. Dad was an engineer in the army during the war. He went back to Germany for a while, to do some work once it was over. I went out there when I was a kid for a bit. He died a long time ago now."

At that point, I saw a group of young boys approaching us with what looked to be their mother. They must have been between four and eight years old.

"Hello!" one of the boys shouted.

"What are you doing cutting this man's hair in the street?" another asked playfully.

I put down my scissors for a minute as Bob and I introduced ourselves. The children took turns yelling their names back to us before the lady spoke. "I just wanted them to see that this kind of thing is what makes the world go around," she said, smiling.

Throughout the haircut, we had countless interactions like this, but it wasn't just conversations that came our way. People were generous; Bob ended up with over sixty pounds in his cup in the end.

"I tell you what," he said, looking at me. "I don't believe it. This many people don't usually stop. They just walk on by."

"I'm afraid it's all you, Bob, and your new look, mate."

At the entrance to the tube station nearby, there was a girl who had been standing around for the duration of my time with Bob. I'd overheard her once or twice, attempting to sell a Travelcard to people flocking in and out. Now that I'd finished with Bob's hair, she walked over.

"I'm sorry, excuse me . . . would you like to buy this? I can sell it for five pounds, but it has more money on there . . . I'm sorry to ask."

Bob looked down at his cup and grabbed some coins and reached his hand out to hers. Her face lit up and she passed him the Travelcard.

"No, it's all right," Bob said. "You keep it."

She thanked him and walked off in the other direction.

"People help me, so I help other people. It's simple, really."

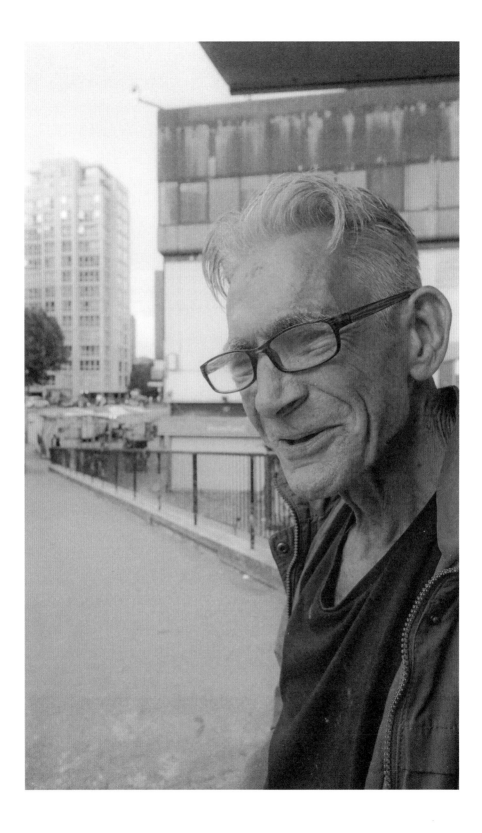

New York

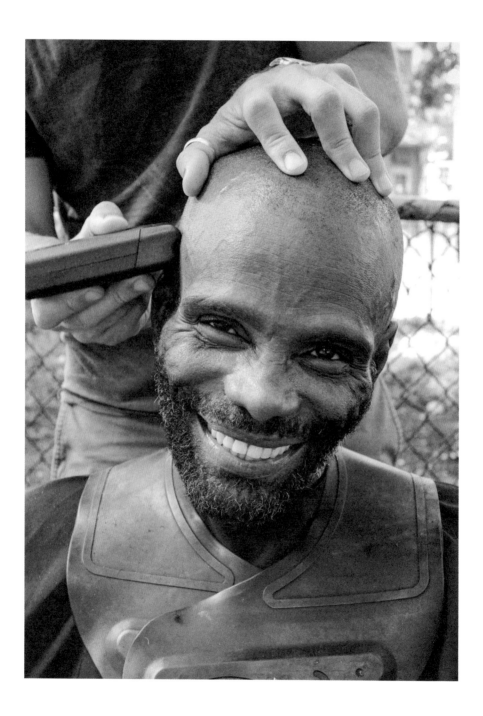

Tony

IT WAS SEPTEMBER AND THE UNBEARABLE SUMMER TEMPERATURE had cooled off slightly. I took the L train from Brooklyn to the East Village and slowly made my way down to Tompkins Square Park. My bag was packed with barber tools, and I was hoping to meet someone like Tony. He called out to me from where he was sitting.

"Hey, man! What's going on?" Tony was leaning back on the bench like it was an easy chair, legs stretched out in front of him. "How's your morning going?" he asked with an infectious grin on his face. I sat down next to him. "I'm Tony Sanchez. Nice to meet you." We shook hands. "What brings you here today?"

"Hey, man, I'm waiting for my friend Valérie to turn up," I told him. "She just got in from Minneapolis."

"Well that's cool. I thought I'd say hello to you when you were walking by. I wanted to talk to someone. I just got back from an appointment at the hospital this morning. I have cancer." Tony must have spotted a slight shift in my expression, because he smiled and began laughing before continuing. "I already knew that I had it, don't worry! It's not getting any better, but it's not getting any worse, so it's good news! I wanted to share that with somebody. I'm happy on days like this. It's beautiful outside."

We kept talking. I had no idea Tony was sleeping on the street until he mentioned it in passing: "I heard about a room that might be coming up for me soon, so I got all the reasons to smile. It's a long way from here, of course, way out in Queens, but it beats the sidewalk."

It wasn't long before Valérie arrived. After almost two years of emailing each other, this was the first time we'd met in person. Valérie Jardin is a beautiful soul and an amazing street photographer, originally from France, now living in the US. I first emailed her randomly in 2015, a few

days before a trip to Paris, and we've been friends ever since. I'm forever grateful for Valérie's help to tell these stories through her lens. I told Tony more about what I do and asked if he'd like a haircut.

"Damn!" he yelled. "Of course I want a haircut! Thank you. Take it *all* off, man. All of it. Nice and clean."

I arranged my clippers and trimmers in a row on the bench. Valérie asked if she could take a photo.

"Do your thing, Valérie, do your thing!" Tony said in his Dominican accent. "I'm ready to rock and roll."

I began cutting his hair. The sun was high, but the trees provided plenty of shade. I tried to convince Tony to keep his beard, but he was adamant.

"It's gotta come off, Joshua. I know you're the barber, but I don't know when I'll next get to shave! I haven't been staying in shelters or anything lately. It's too much in this heat, surrounded by so many other people."

Tony was seriously charismatic. His energy created a buzz and we laughed a lot together. I was interested in how he remained so upbeat while not knowing where he'd lay his head each night.

"I've come a long way, man. My dad's an alcoholic. It wasn't pretty . . . My mom was everything to me. She died back in 2000. I know she's looking down on me and I take a lot of strength from that. I want to put out a message to inspire people that I'm a survivor. I'm living with cancer, on the street, and I'm still smiling. So be optimistic."

Tony meant every word, I could feel it. They cut through more than any "motivational speech" I've seen delivered onstage. I hadn't been paying much attention to the people on the benches around us. It had gotten busier as the afternoon ticked on. Sitting on the bench opposite was an older man with floppy grey hair who kept glancing in our direction. He nodded at me, so I said hello and invited him over to join our conversation.

His name was Janusz, and after a few minutes he asked timidly, "Do you think . . . Is it okay for me to go next? For a haircut?"

"Of course," I said. "Give me a few minutes and I'll be finished here with Tony." I used some wipes to clean any loose hairs from Tony's head and handed him a mirror.

"Oh, this is better. A lot better. Yes, yes, yes!" Tony exclaimed.

I looked to my left where Janusz had been sitting. I was ready to call him over, but he had disappeared. I spotted him in the distance moving toward the park's exit. I called out, but he didn't hear me, so Valérie ran to see where he was heading. In the meantime, Tony had to leave, so we said goodbye. I hadn't noticed how frail he was until I put my arms around him. I wished him well and thanked him for saying hello to me that morning.

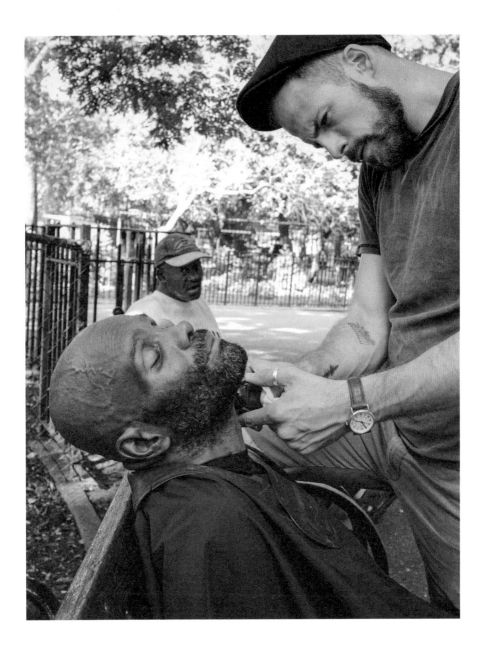

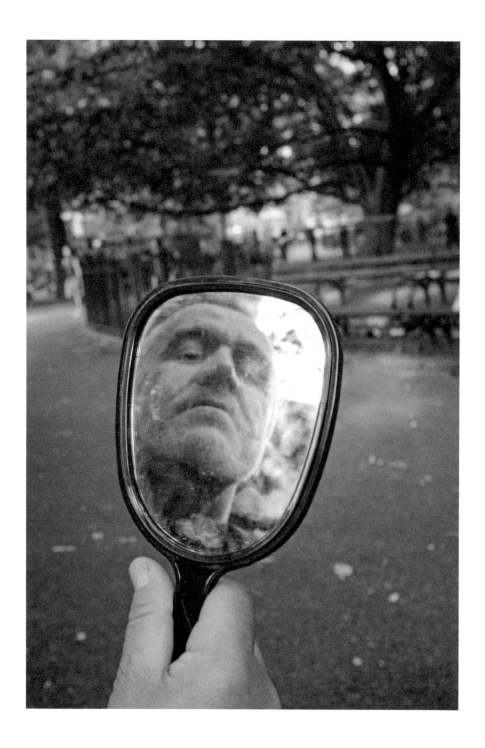

Janusz

IT WASN'T LONG BEFORE VALÉRIE RETURNED with Janusz, who looked slightly embarrassed.

"Hey! What happened?" I asked.

"Oh . . . I don't know . . . I just thought that my hair is dirty, and I thought probably you don't want to cut it this way. I want you to do it, but maybe tomorrow we could do it instead? I can try and wash it in the shelter tonight."

I've run into such apprehension many times. It's not easy to make somebody feel instantly comfortable. I do my best to dissolve any concerns, and dry shampoo usually helps. I take it from my bag and spray a small amount into the air, endorsing its ability to clean hair without water, using my best sales patter, which worked with Janusz, thankfully. He sat down on the bench and I wrapped a cape around his shoulders.

Janusz grew up on his family's farm, in the countryside near Kraków, Poland. He migrated to New York with his mother in the 1970s, when he was a young man.

"I would work many days when I was young . . ." Janusz had retained a slight Eastern European accent. "They were long days. We never stopped. It didn't get easier as I grew up. We were struggling, so my mother decided that we should leave. It wasn't possible for everyone to come with us to America."

Janusz had been homeless for four years when we met. He spoke of his last job and how it ended. "I was working doing deliveries for a long time, for different companies, but I'm getting older now, lifting things becomes more difficult. I had an injury one day with my back, I took some time off and there was no support. I was only staying in a small place, but I couldn't keep it for long."

In contrast with Tony, Janusz was clearly exhausted and downtrodden. He was trying his best to navigate the city's shelter system, a daily grind for a bed each night, at sixty-five years old. As I finished cutting and styled his hair into a quiff, another side of his personality emerged.

"You make me look like George Clooney now, yeah?" We all laughed.

He held the mirror and stared at his reflection for a few seconds before glancing away. When he looked back, his face broke into a smile and he started chuckling. He rubbed his eyes in disbelief and looked again, his eyes wide. "This is fucking crazy . . . Thank you, guys."

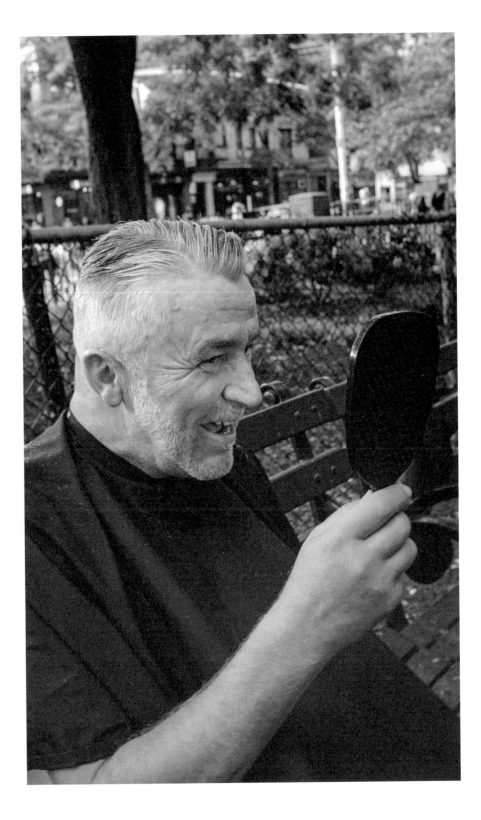

Eveylon & Terry

THE WEATHER TURNED THE DAY AFTER, so Valérie and I headed toward Grand Central, expecting people would be taking shelter there. I stopped at a café for some coffee. Waiting in line, I looked out the window. The rain began to fall, and umbrellas sprouted up from the crowds. Farther up the street, I could see a boy and girl sitting outside a deli, stretching a waterproof cover across the bags in front of them. I went to speak with them.

Eveylon and Terry had been sleeping on the streets for almost six months after missing rent on their room in Brooklyn. I threw out the offer of a haircut so we could chat some more.

"What?! Yeah, you bet!" Terry shouted. "Ah, man, I've been waiting to get it done . . . I guess I was waiting for *you!*"

I ran back to the café and asked to borrow a chair, then we found some shelter in an underpass nearby. Eveylon was up first. She had mountains of hair and only wanted a trim, but I could tell she needed to feel pampered. She and Terry were open about their addictions and their pasts. Neither of them had an easy upbringing. Eveylon began speaking about a previous relationship.

"Looking back to my ex-boyfriend, I can't see how I let someone treat me that way. It was so unhealthy. I was feeling vulnerable and just wanted love. That can blind you sometimes, you know? He did some horrible things to me that I don't talk about. It couldn't be more different with Terry, though. We respect each other."

Terry put his hand on Eveylon's shoulder, bent down, and kissed her. A few passersby gave strange looks, wondering what we were all doing.

Eveylon continued: "We're used to those looks. Someone even walked past us recently and said, 'You can't be homeless because you look too

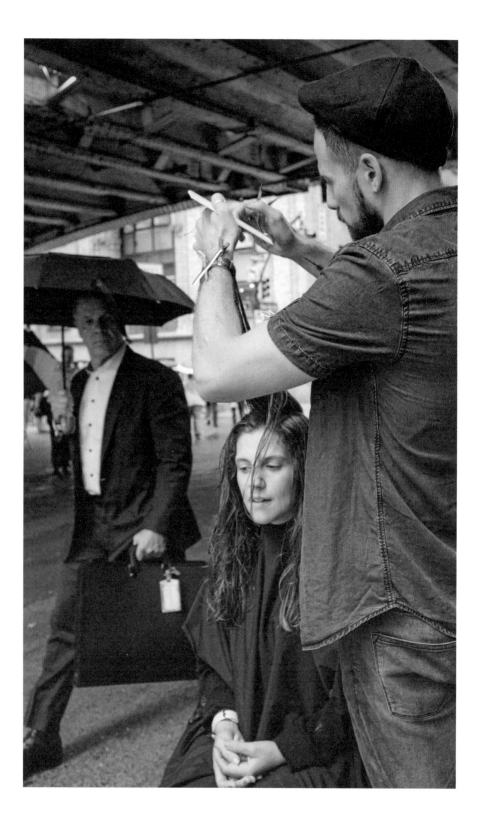

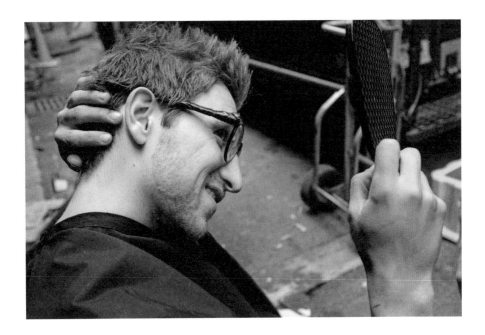

happy.' Can you believe that?! But it's true . . . We are happy in the sense that we haven't got much at the moment, but we have each other, and that's amazing."

As I cut Terry's hair, I noticed some bruising on his eye and head.

"Yeah, somebody tried to rob me last week. It's no big deal. I mean, I wasn't that chill about it at the time, but . . ." Terry chuckled. "It's okay. They didn't get anything. Plenty of people will try and mess with you, it's the nature of things out here."

Eveylon and Terry's affection was real; their love ran deep. They had a battle to fight. They were on a methadone prescription and working a program toward abstinence. It hadn't been easy for them to attend all of their NA meetings while looking for the next place to sleep. Most night shelters are reluctant to accept couples.

Eveylon and Terry's energy really stayed with me. I was able to visit them again with my friend Hal Samples a few months later, on my next trip to New York. I cut Terry's hair once more and we spent time together talking. The bitter chill of winter had set in. They were still out on the streets, but luckily they'd been able to get some nights inside at a friend's place from time to time.

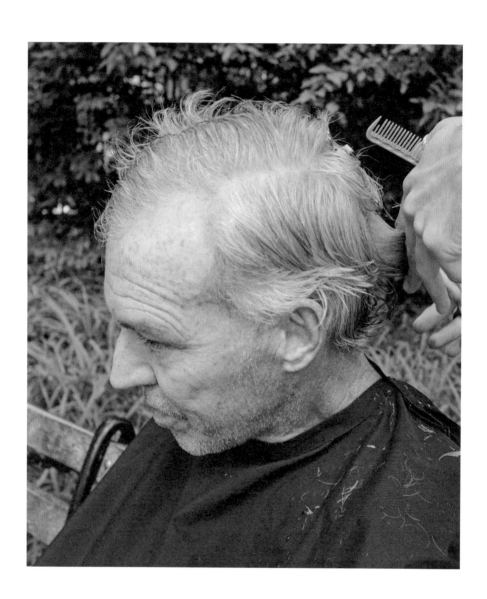

Irish Mike

I TEND TO CUT THROUGH WASHINGTON SQUARE PARK at least once or twice when I'm in the city. On a clear day, you'll find crowds of people scattered underneath the arch, or seated on the steps around the fountain. I thought back to a group I'd met on a previous trip, a year prior, who were sleeping on the periphery of the park, basically in the bushes. Even that humble spot on the grass, away from the selfie sticks, had proved to be a problem for local authorities, who tried to move us along as I was cutting hair.

Thankfully, nobody bothered Valérie and me for the duration of our time with Mike, whom we'd met on a park bench this time around. "Actually, it's Irish Mike," he said, turning over both his arms, revealing the words tattooed in black ink and Gaelic type on each wrist. "That's how everyone knows me." From the moment we greeted him, Mike was talkative and friendly. He grew up in Bergen County, New Jersey, before moving to Albany in upstate New York, where he'd spent most of his life. He came to NYC six months before we met him, after getting out of prison.

"It's been almost ten months living on the street. I wound up with the wrong crowd, and that landed me in jail. I was put in an apartment in Albany for a month when I got out, but I was in there with a guy who had a lot of problems. He flipped out on me one day because there was too much water on the floor of the bathroom, and went after me. I didn't wanna go back there after that. My friend invited me to the Narcotics Anonymous convention for the weekend, which was good timing. He paid for me to get up there. I saw a bunch of friends I hadn't seen in a long time. I was active in the NA community for years. It was a sober venue, 'allegedly.'" Mike made air quotes and laughed. "But everybody there is on some kinds of meds. Welcome to America . . ."

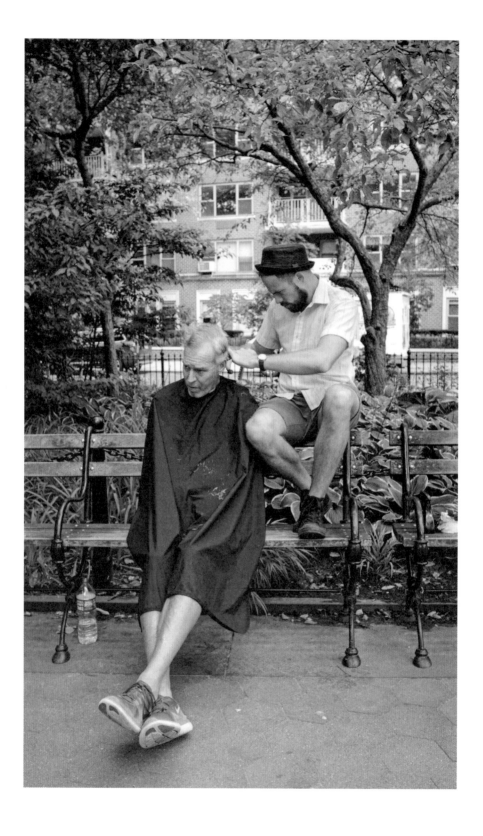

I was curious about what support was available upon his release from prison.

"Oh, there was support," Mike responded sarcastically. "'Go to the mission,' my parole officer said. But honestly . . . I haven't enrolled myself in all the support that I know is available, specifically food stamps. I ran away from it. I wanted to see if I could survive without it, and I have. When I came to New York, I went to the men's shelter over in Bellevue, it was horrible. That was worse than prison, so I started looking out for myself. I heard about an organisation called City Harvest and began volunteering myself. Different restaurants will put out food for us. We'll collect it."

Before I got to cutting his hair, Mike pointed out a large wound on the back of his head. It was deep, but it had started healing, so I worked around it.

He continued: "Because I know where most homeless people are and where they hide. I know some of their issues. Now the restaurants know me because they see me all the time, which helps. They say, 'Hey, Irish Mike! You need any more food?' I'll collect pizza from Carmine's or Junior's, or wherever, and gather up meals and buy a few bottles of water and put it out for the younger guys who are sitting in doorways, doping, so that when they wake up, they have something to eat."

I could tell Mike wasn't looking for kudos. This was an embedded code of ethics, a program he was adhering to.

"You don't know what it's like to live on the streets until you've done it. Depending on the environment you're in, a few drinks can easily transition into relying on something harder. It may sound strange, or hard to believe, but it's almost as if it happens without you knowing about it . . . You wake up one day and think, *Shit, am I an addict?* The answer was yes, and I had to do something about it."

Mike remained seated in the same position we'd found him in as I danced around, gradually trimming his hair down, taking off some length as he'd requested.

"I have to go to the Coalition for the Homeless later today, over on Fulton Street, to get my social security started. I should get it in a couple weeks and have a decent amount of money to move around with, so I can finance a trip to the West Coast. I am NOT doing one more goddamn

cold winter! Albany slaughtered me this year, fifty-five inches of snow in seven days, subzero. I was out for all of that. I'd stay most nights at the mission, but I was out on the street for eighteen hours a day. The plan is to stick around here for another month or so. There's so much good music happening. I haven't actually been inside a concert for a while, but I can stand outside. The last concert I saw was Asbury, Southside. The Stone Pony in Jersey has an outdoor venue, and across the street the sound is actually so much better."

Mike spoke of upcoming concerts like the tickets were already in his pocket, the reality being that he just went to the venues and listened from afar. I thought that was pretty cool, to be honest. Music was clearly something that kept him going.

"It's absolutely critical. I usually always have an FM radio with me. Either way, music is always with me in my head. I like everything. That's why I love it here in Washington Square Park, there's all kinds of live music happening. There's jazz over there, and the piano man plays down that way." Mike pointed across the park.

I tapped my hands on the bench, imitating a drumroll, before Mike looked at his reflection in the mirror.

"Oh wow . . . I look like a new man. Just call me Mike, Mayor of the Park." He grinned. "When you guys first came up to me, I thought you were going to start preaching at me, but I'm feeling great, man. Thanks for looking after me today."

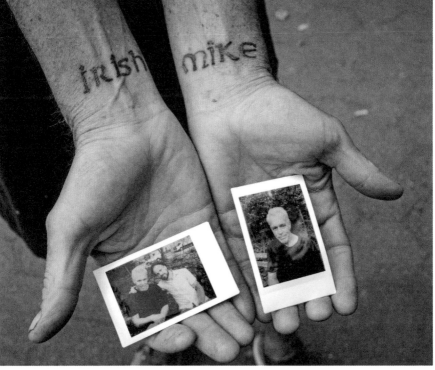

Washington, DC

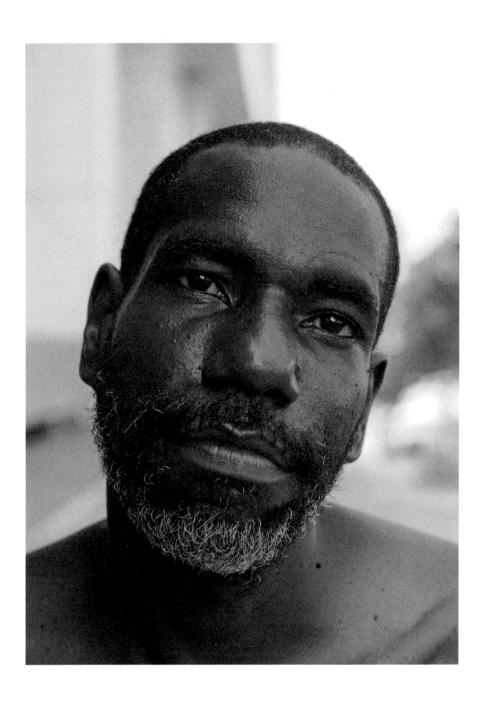

Dennis & Tiana

IT WAS LABOR DAY, 2018. I grabbed my case from the overhead rack and stepped off the train and onto the platform at Union Station—Washington, DC. Fresh air was accompanied by the sound of a street musician playing his saxophone near the entrance. I leaned against a pillar in the sun for a minute. An American flag was draped high from the front of the building, the stars and stripes dancing in the wind. I dropped some money in the saxophonist's case before making my way across town to where I was staying.

The next morning, I charged my clippers and got out early. The sun had turned up the heat. I slowly weaved my way back toward Union Station on foot. You don't have to venture far from the squeaky-clean streets of Capitol Hill to experience another reality. Poverty is sky high in the nation's capital, and it's evident in just how many people can be seen sleeping rough. I headed up toward NoMa, a neighbourhood in Northeast DC. Gentrification had bulldozed it in recent years, leaving behind luxurious, vapid condos. I chatted with a group living beneath a highway, some of whom still held down day jobs while sleeping in tents at night. One lady spoke to me of the stark contrast in NoMa, how the city's efforts to "clean up the streets" had increased tenfold as soon as rich white folk moved in.

When I got to Union Station, I saw a man and woman standing by a side entrance. The man was tall and wearing shorts and no top. His long limbs were muscular. Grey hairs peppered his beard, but he looked young. The woman was much shorter. Her frizzy black hair was tied back in a ponytail. I headed over to introduce myself, and they were immediately welcoming.

"I'm Dennis and this is Tiana," the man said.

Tiana smiled at me. "So, you're here from London? Damn! How do

you like it here in DC?"

I told them that I'd been in town a year earlier, and that I'd given haircuts to some people on the street not far from where we were standing.

"Oh, that's cool . . . You're trying to see the *other* side of the place?" Dennis said. "I get you. Well, in some ways, this is rougher than the neighbourhoods. As far as just being able to be who you are each day. Union Station can be deadly . . . You can account for that?" He glanced at Tiana and she nodded in agreement. "It might look peaceful, man, but Union Station can be a death trap. I know so many people that got stabbed, died, everything. It's a transportation hub and that makes it dangerous. People come up here so nonchalant, like, 'Oh, we in DC,' but they just don't realise a lot of people prey on tourists. They prey on them, and if they don't know you, man, you are got. I've seen it so many times. It's sad . . . Everyone's trying to get somewhere by coming up here. You can feel the tension. They hustlin'. For me though—people will tell you—I'm homeless, but if I see that you don't have, I would give you my last . . . I would give you my last, because that's a blessing that will come back to me."

I asked Dennis and Tiana if they wanted to find somewhere in the shade, so we walked over the grass, crossed the street, and perched on a wall. Dennis had his arm around Tiana now. She gazed at him affectionately. I could feel the love between them. I'd later find out that they'd met in a public library. Neither realised the other was living on the streets until they started talking. I was interested in what Dennis said about good things coming back to him and where this ethos came from.

"The thing is, I'm not really looking at it in any particular way. I'm just helping out the next man that needs something. That's what I'm known for up here . . . Not for the hustlin' thing, or none of that. If you need something and I know I got it, I'll give it to you. She gets on me all the time about that . . ." Dennis gestured toward Tiana and smiled, showing a large gap in his teeth. "But that's just who I am. I've gotta give to the next person that has less than me . . . I gotta do that."

It felt like a good time to offer him a haircut.

"Man, that would be a blessing. Can you take it right down to the skin for me?"

I took out my clippers and foil shaver and set them down on the wall next to us. There was a café across the street; people were sitting outside,

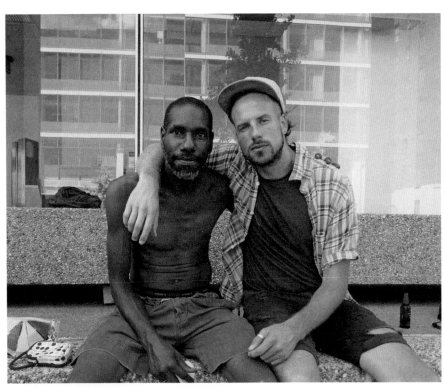

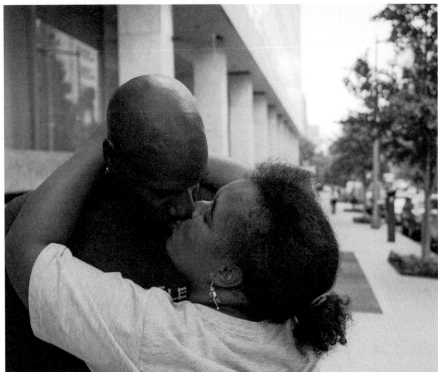

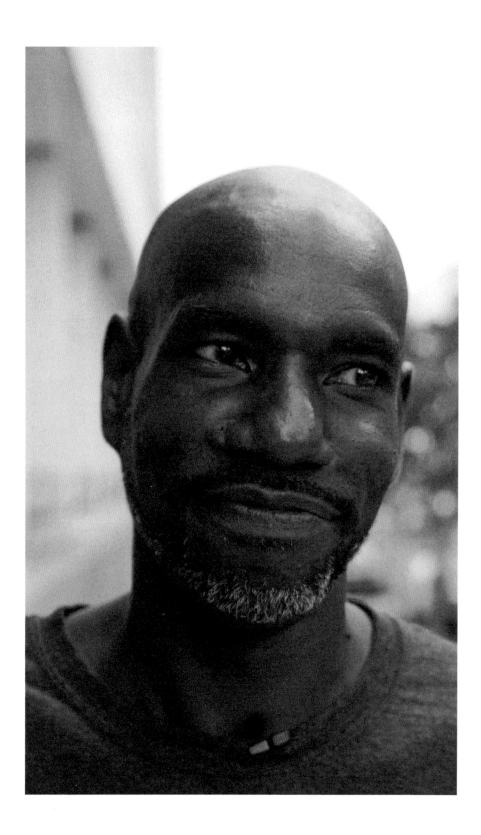

drinking coffee and eating lunch.

"Actually, I gotta go pee before you get started . . ." Dennis laughed. He put his T-shirt on and headed across the street to use their restroom. It gave me and Tiana a chance to talk. She began speaking about how they got by each day.

"There's help, but it's really hard to find places where we can both stay inside. We have to rely on each other to get by, but I wouldn't have it any other way. I make jewellery and we sell that when we can. He helps me with that now too."

"Tiana was telling me that you guys make your own jewellery?" I said excitedly when Dennis returned.

"Well, she makes most of it, but I've learned to help her. It turns out that making earrings and stuff is a hidden talent for me!" Dennis laughed. "What have we got, like, twenty earrings right now?"

"Hmm, yeah, maybe fifteen or twenty," said Tiana. "We keep them locked up near the station."

"Maybe you should go and get them to show Josh?"

Tiana smiled and quickly disappeared down the street, back toward Union Station.

"Don't run!" Dennis shouted after her. "We're still gonna be right here." He shook his head and chuckled. "We still gotta finish this haircut yet."

I rubbed the shaver across Dennis's head until it was shining. I moved in front of him and began shaping his beard. His voice became soft and quieter.

"I've gotta help her, man. That's my focus right now, to help her get out of this situation. I don't care about me. I can make it. I can survive day by day, but I've gotta help her, because she's been on these streets too long now."

"How long have you guys been together?" I asked.

"It's been a year, and within that year we've got her birth certificate back, her ID, she's started studying again and applied for a job. It sounds crazy, but my thing is, even though I'm struggling, I think God put me here to help other people. You know, because everybody I've helped has got themselves together and moved on, and I'm good with that . . ." Dennis looked away from me and down the street. Tears appeared in his eyes and one rolled down his face, leaving its track on his dark-brown skin.

"So . . . that's where my shit is right now, you know what I'm sayin'?"

"Yeah. I know what you're saying," I replied. "But what is it that makes you feel that way about the people around you? You're in a time when you need more than most, and you're seeing beyond that somehow?"

"It's cuz I've been there, man. I had everything—apartments, cars and all that. So, I understand it's not easy to be out here every night. People with no money, getting high just to stop what's going on in your brain. I'm trying to learn to give without wanting . . . without wanting *anything* in return. But it's hard . . . It can be like crabs in a barrel. Why is it so hard to want to see the next man do all right? If I see the next man down, I've gotta try and bring him up. Even if it's just a little bit. So he knows there's at least one person out there who's not just trying to get one over on him. That's where my heart is at. Maybe it's my age that's humbled me and brought me to that point. I dunno . . . That's my story."

Dennis threw his arms up in the air as if to say, *I give up*, then slapped them down on his knees. He looked spent for a moment. I wanted him to know that his words hadn't fallen on deaf ears. I reached out to him. We locked our hands together and held them there for a while, looking at one another.

"I know I'm gonna get out of this . . . I just think this is my time to help other people."

Tiana came back with a spring in her step and some of their jewellery to show me. She put on a pair of earrings. We sat together on that wall for a while longer. I was coaxing Dennis for tips on how to stay so trim when I reach my forties.

"I've been this way all my life, man!" He laughed. "I eat one meal in the morning and one meal during the day and that's it. I guess I have a high metabolism or something."

I said goodbye to Dennis and Tiana and left them to get on with their day.

"Everybody out here is looking for money," Dennis said as we moved away from one another, "but it's the little things that count to make somebody feel better about themselves."

Denver

Zero

"**E**XCUSE ME, WOULD YOU LIKE TO READ MY SIGN?**"** This question was asked to hundreds of people who walked past the corner of 16th and Welton Streets, on a miserable October day in Denver. It was my first time in Colorado. I'd woken up on the wrong side of a cheap hotel bed after travelling from Texas the day before. It had been raining heavily all morning. When it eased up, I decided to get out and explore. I didn't know if it was just the weather, but catching a smile felt about as likely as the sun coming out. I walked up one street and looped back around. I was thinking of heading to another neighbourhood when I heard a loud voice up ahead. I followed it until I reached a young guy standing and holding a cardboard sign, calling out to pedestrians. This was Zero. Meeting him was a welcome break.

"Would you like to read my sign, madam? No? Okay, no worries, have a great day!" he called after a lady who had just declined his offer. "Hey, sir, how about you? Would you mind reading my sign for me? It will only take a second."

Zero carried on like this until another woman stopped to read it.

"Happy birthday!" she exclaimed.

"Thank you!" Zero shouted with a big grin on his face.

It was his birthday. I moved closer to read the words written in black marker on the battered piece of cardboard: *it is my b-day anything would make my night God Bless.*

"Happy birthday!" I caught him off guard.

"Thank you, man, I appreciate it!" he shouted back to me. There was a shopping cart behind him stacked with all kinds of things—shoes and sweaters, a sleeping bag, empty plastic bottles. A cooler hung from the back.

"Mind if I hang out here for a while?" I asked. "What's your name, by the way?"

"It's Zero. Sure thing. Stick around."

I stood there in his shadow and watched as he continued in the same way. A social experiment began to take place.

ZERO: Excuse me, sir, would you like to read my sign?

MAN 1: Nope.

ZERO: Would you like to read my sign, sir?

MAN 2: Umm . . . [*Pauses and looks distressed, but reads the sign.*] Happy . . . birthday?

ZERO: Thank you! [*Sees WOMAN 1 walking by.*] Excuse me, would you like to read my sign?

WOMAN 1: I'm sorry, I don't have anything.

ZERO: That's okay, you don't have to give me anything. I'm just asking you to *read* it.

WOMAN 1: Oh . . . Happy birthday!

ZERO: Thank you! Have a great day! . . . How about you, sir? Would you like to read my sign?

MAN 3: No. [*Stops, then moves closer.*] Just because you can't get what you want, you think that gives you the right to be an ass? You're rude!

ZERO: Well now you're being rude.

MAN 3: You wanna come make me stop being rude, you dick?!

ME: Hey! Calm down, mate.

It was a bit unexpected, but I'm sure Man 3 had a good reason to lose his shit. If you sided with him at the end there, I'm sure you have a good reason too. I get it, we're all busy, and yes, Zero had written *anything would make my night* on his sign, alluding to a need for money or food. But it was obvious that his intent was nothing more than to have some fun on his birthday. I liked his approach. Rather than sitting and watching the world, with nobody to celebrate with, he flipped it completely and was unfazed by the negativity that came his way.

"What's the ratio been like?" I asked. "How many people have stopped and wished you happy birthday?"

"Hmm . . . around half, I'd say. Yeah, about half-and-half. Which is pretty good! But I've gotten better as the day has gone on. I've got my ID here if you don't believe me."

I believed him, but he passed me his card all the same, and sure enough, it was his birthday. It said *Ohio* at the top.

"Is that where you're from?" I inquired.

"Yep. I haven't been back in a while though. I've been on the road. I came to Colorado a few weeks ago."

"Hey, Zero, do you feel like a birthday haircut?" I asked him.

"Huh?" He looked confused. "Umm, where do I go for a birthday haircut?"

I set my bag down and explained.

"Hell yeah! So I don't even have to move from this corner? Perfect. How short are we going? I think I wanna keep some beard . . . Apart from that, you do your thing. I trust you."

I began snipping the length from Zero's hair and joined him in beckoning people toward his sign. It was fun.

The rain was on and off, prompting breaks in the haircut. Zero passed me some tarpaulin that he had in his cart to cover my clippers and anything battery powered. We took shelter under the doorway behind us. I asked him where he slept at night.

"Hmm, wherever. I had a tent, but I had to leave it one morning because a ranger came and said I couldn't pitch it where I had. They took it away. I'm not sure if I can get it back. I don't usually carry this much with me, but I've accumulated some things. I'm the master at this though." Zero rested a hand on his loaded shopping cart. "Do you know how much it weighs? You've gotta know how to turn it right. I push this thing up hills all over town."

A man looking pretty worse for wear hobbled by slowly on the street in front of us. He stopped, pulled his hood down, and began scanning the wet ground at his feet, as if searching for something he'd lost. His attention moved to a trash can, and he walked over and reached one hand inside, seemingly unaware of the busy streets around him. Another man walked past with a pretty disgusted look on his face and shook his head.

"I don't like that," Zero said. "When you see people bully people who are struggling mentally . . . that's not cool. If you're looking down on somebody who doesn't have the mental capacity to defend themselves, it's bullying, that's what it is."

When the rain cleared, I got back to cutting. A minute later, some-

body stopped to read Zero's sign. They wished him a happy birthday and offered him a beer from their bag.

"Thank you! I'm gonna say no to the beer though," Zero replied graciously.

"What? You don't drink?!" the stranger exclaimed.

"No, I don't like the taste of beer. I'll stick with the birthday joint I have in my pocket here, but I appreciate it all the same!"

I tucked the cape into Zero's sweater to shave the last of the hairs from his neck, then brushed them off onto the concrete. Just as we were finishing up, a young couple stopped at the crossing with their toddler in a stroller. The mother pulled the extendable hood back so her little girl could see me and Zero. She couldn't have been more than eighteen months old. Zero waved at her and she shook her arm back at him. "Hang on," he said, before leaping up. He rushed over and kneeled down next to her. Holding his hand up, he said, "High five." Her parents were laughing and encouraged their daughter as she extended her hand to touch Zero's. Children often react like this, with a natural curiosity that seems so organic at that age. There are usually two types of parents: the ones who nurture and allow these interactions to flow, and those who tighten their grip to forbid them. I feel that these moments are pivotal in our social development.

A few minutes later, I handed Zero my mirror. He took it, then puckered his lips before looking at himself. Everything was a joke with Zero. He didn't seem to take life too seriously. I had a lot of admiration for that. He reached into his pocket and lit a joint before springing up onto his feet. "Thanks, dude! Hey . . . I feel like we're the exact same height. I hadn't noticed that."

I spent the rest of the afternoon on that street corner with Zero. We shared some pizza as it got dark. There's a different nighttime feel to downtown in most cities, and Denver was no exception. As the stores closed, shoppers vanished, leaving those who had nowhere else to go visible. I was unsure of how I'd spend my time in the city, but meeting Zero was worth it. He was full of energy. I know some found him irritating and looked down on him with contempt, but he was a self-esteem machine to me and anyone else who accepted him.

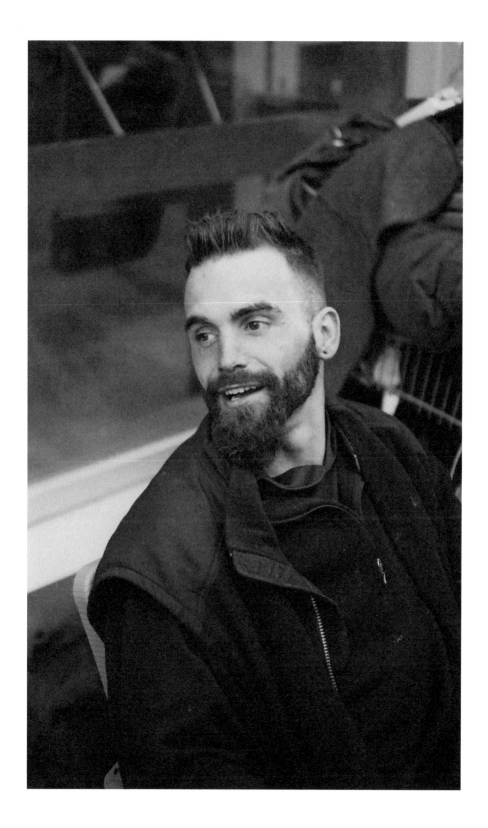

Boulder

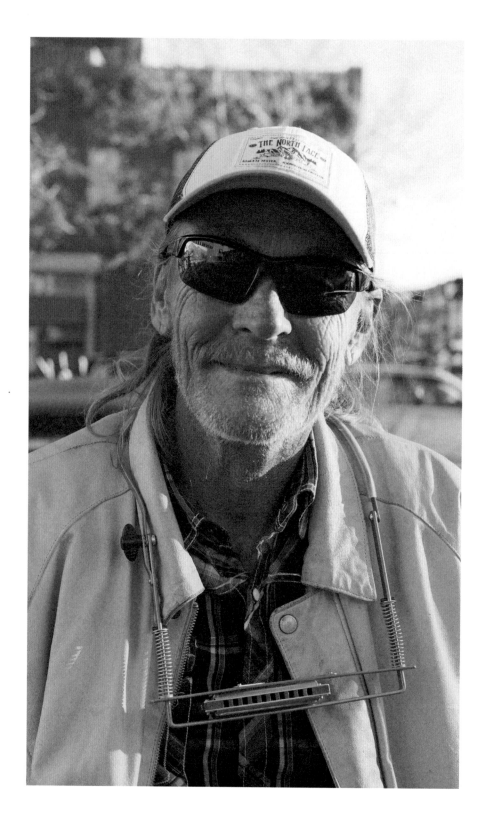

Paul

I TRAVELLED AN HOUR NORTH ON THE BUS from Denver to Boulder, with plans to spend a few more days in Colorado. I was standing at a traffic light downtown when I clocked a man crossing the street in my direction, a harmonica clamped in a metal rack around his neck. We greeted one another like old friends who always met in the same spot, I'm not sure why.

"Hey, how's it going?" I chirped. I hadn't spoken to anyone for a couple of days and was in need of company.

"Hey! I'm good, I'm good," he replied. "Thanks for asking. Enjoying this fine day. How about you?"

We exchanged introductions. Paul's beige, button-up leather jacket bore marks of age, matching the deep-set wrinkles that trickled out from his sunglasses and across his cheeks. I'd later learn that Paul was in his seventies, but if I'd closed my eyes, his surfer-dude accent could easily have belonged to someone thirty years younger. His strawberry-blonde hair was tied in a ponytail that sprang out from the back of his hat like Willie Nelson.

"I play harmonica too," I said. "Well . . . a few blues licks."

"That's great! I don't go anywhere without mine," Paul replied. "I just traded in my guitar, otherwise I'd play you a song. Some Neil Young, probably. I was playing 'From Hank to Hendrix' out here on the street earlier this week before a snowstorm came in. Then I decided to sell my guitar to buy this Corolla." He gestured at a black Toyota in the carpark of the bank behind us. "I had to weigh it up, and believe me, that was not easy . . . I already miss my guitar, but now I have wheels, which gives me my freedom and, more importantly, somewhere to sleep."

"So you're sleeping in your car right now?" I tried to sound as casual

as Paul.

"Yes—it's getting colder and winter is coming . . . Anyway, man, where you from? You don't sound like you're from here. Are you visiting?" Paul perched on a wall next to his car. The afternoon sun spilled over the distant mountains and into the city. I sat next to him.

"Yeah, I'm just visiting," I said. "I have a couple more days here. I like it."

"Me too, brother. That's why I came to Colorado, to get away from everything . . ."

We kept talking there for some time. Paul seemed completely comfortable in his skin, a rare quality. He was a good listener too. Taking moments to ponder calmly, allowing words to simmer awhile before responding. The temperature had dropped so I grabbed a jacket from my bag.

"We can sit in the car if you want," Paul offered. "I can put the heater on in there."

The interior was about as beaten up as the outside, but spread throughout was a small gallery of Paul's life, giving it some charm. Neatly folded clothes lay on the backseats. Cardboard boxes overflowing with notepads and books filled the footwells below. A big winter jacket hung from a hook on a handle, eclipsing one of the back windows. Black gaffer tape, wound tightly around the steering wheel, looked as though it held the whole thing together. Paul put the key in the ignition and the engine coughed before finally coming to life. The radio clicked on a second later. He fiddled with the heater until warm air began to drift in. I spotted a notepad on the floor by my feet. "Oh, I don't want to step on this," I said as I picked it up and handed it over.

"No worries, man. Sorry, my shit is all over the place in here!"

I glanced at the pad. It was a black composition book with Paul's name scribbled on the front. I was immediately curious. "What is this? If you don't mind me asking?"

"Oh, no sweat. It's one of my songbooks. I've been writing a lot recently . . ." He began turning the pages. "A lot of this is a therapy for me. They are songs, but they all start with a feeling." Words and sketches spilled across the pages in blue and black ink. Paul stopped on a song titled "Nowhere to Go."

I asked if I could take a look. My eyes scanned the lyrics:

Nowhere to sit and nowhere to go
I think I'll lie down on the road
They make it tough when you don't have a home
And seeing the desperate eyes of the homeless
Looking at me like I might know
God and I should know, that's for sure
Nowhere to sit and nowhere to go
I keep my eyes upon the road
A policeman just ran my name
And said don't ever sleep there again
God I am so down
Has my time on Earth here expired?

Cars funnelled in and out of the carpark as the sunlight slowly slid away behind the buildings. The car had warmed up by then. As I scrolled through his book, Paul rolled a joint. He cracked his window before light-ing it up, inhaling the first drag deep into his lungs.

"So, did you come up through Denver? I go there from time to time, but I prefer the pace up here. Even though I have the car to sleep in now, it still depends on the weather. I need to be inside if it gets too cold and there are more homeless services down there."

I told Paul that in Denver I'd seen the familiar sight of people hooked on opioids, lying on the footpath in some areas, in the worst addiction epidemic in American history.

"Yeah, man. I feel you. We're all hooked on something . . . everybody. It's the same anywhere you go. People are strung out for one reason or another. We're not as aware of one another as we used to be. People don't respond to each other in the same way, and we're afraid to interact. I think now more than ever before."

Paul was right. Fear digs a hole to dehumanise addicts and—especially when it comes to those in the already vulnerable position of living on the streets—all but buries them alive. Mainstream media outlets cover the crisis with soulless commentary dubbed over unflattering footage, taken from afar. I'm not going to pretend it's an easy bridge to build at the sharp end. Walking through some neighbourhoods in America can be a difficult

experience. There's no time to build a connection when someone is bee-lining for their next hit. Narcan, used to treat opioid overdoses, is more useful than a warm smile. The state counts bodies while the communities provide frontline advocacy, bearing the weight of the suffering and constantly pushing for change. NGOs, and the unwavering devotion of the humans behind them, are the last safety net for so many who have fallen between the cracks.

"I wrote a song just recently," Paul continued, "called 'Doctors and Pharmacists'. I'll play it for you one day. But basically it's about drug users. Myself included. When I first came to Colorado, I went to the methadone clinic and got on a prescription. I haven't touched heroin since. That was two years ago. I came here to get away from everything. I take this stuff called Suboxone now. It's like methadone but less invasive. You put this little strip under your tongue. I'm supposed to take three and a half a day but I only take one, because I don't wanna get strung out. They gave me another drug to take at night, Seroquel, it's a sleeping drug, and I'll tell you what, man . . ." Paul's eyes opened wide. "Coming off that shit is worse than getting off heroin, I swear. I have friends who are ex-addicts. It seems like people who go to the extremes with substances, and manage to find a way back, they gain something. I don't know what it is, but they gain another kind of knowledge. I've seen what the other end of the spectrum looks like, though, and it's not pretty."

"Where did you grow up?" I asked.

"In Eureka, Utah. About an hour south of Salt Lake. I grew up there, then I moved to California for some time, then on to Arizona. Music is everything to me. I would never have married my wife, Laura. When I was nine and she was six, we started playing piano and guitar together. Fast-forward to 1989, we got married." His expression slowly changed. "Then fast-forward to 2010, that's when we started doing heroin together. We started dealing, while working two jobs to make it all work. Then we started to embezzle money from the State Bar of Arizona and got caught. That was the beginning of the end . . . She went to jail for that. The night she went to jail, I said, 'Fuck it. I'm done.' I went cold turkey and she went cold turkey too. Then some days later, I ran into my son, Adam. My son was never a little kid. He started doing drugs early in his life. Then he got into harder drugs, like heroin. When we found out, we tried to help and

said, 'Don't bring that in the house,' but it didn't make a difference. One night, I was doing the dishes. Laura and Adam were in the back room. She comes out and she says, 'Hey, Paul, you've gotta try this.' I went back there and the next thing I know the dishes are doing *me*. That's how I got started. We smoked heroin for the next three years. Then my mom and dad died. I started shooting not long after."

Paul's joint was coming to an end. He was deep in thought, watching the smoke kiss the car window before it drifted outside. His warm, relaxed tone made for easy listening. His pauses created a rhythm that kept me holding on for more. He spoke in depth about his life before Boulder and seemed to enjoy recalling pieces of his time line, like putting on a familiar record. But when speaking about his family, his demeanour clearly shifted.

Paul went on in a similar vein: "See, that's the thing, I've always been functioning, no matter what's been going on in my life. And I'm telling you . . . heroin holds no prejudice. It's not prejudiced toward any group. Heroin takes people out of every sector of society. It's funny how it works like that. People can get started by taking pain pills. One guy in particular I think about—his name was Simon—used to come to my house every morning for a while. He was some kind of real estate tycoon, drove a real nice car and everything. Every day, when he was done buying heroin off me, I'd walk out to his car with him and we'd talk for a while there in the street before he went to work. You'd be surprised at the people I'd see. Doctors, lawyers. People go to work every single day, looking just like everybody else . . ."

The day was coming to an end.

"What are you doing tomorrow?" I asked.

"Well, I'm headed down to Denver this evening to meet a friend and stay at their place. But I'll be back up this way tomorrow."

I asked if he wanted to meet for breakfast.

"I'd love that, brother. Does ten a.m. work for you? I'd give you my phone number but . . ." Paul fumbled around in his jacket until he pulled out an old phone with a taped-up case. "I don't think I have any battery right now."

"How about we just meet here in the same place?"

"Great! It was good to meet you, Joshua. I'll see you tomorrow."

It snowed that night. I hoped that Paul made it to his friend's.

* * *

The next morning, I walked twenty minutes to the place we'd spent the afternoon. I spotted his Toyota immediately and smiled. A knock on the window prompted Paul to open the door hurriedly and usher me in.

"Hey, man! Come in out the cold. How are you, Joshua?" Paul was as mellow as the day before.

We drove through a suburban area where the houses were tall and beautiful. Magnificent red, orange and green trees lined the streets, all draped in a white sheet of snow. We got to a main street and found a diner. It was warm inside and smelled like pancakes. Seated at a table by the window, we ordered coffee and got our menus.

"Wow . . . I haven't had pancakes in a long time," Paul said brightly as his eyes scrolled down the menu. "Maybe I'll get some eggs on the side."

After a refill of coffee, the food came and we sat talking.

"I wanted to play the piano so much recently. There's a place over here, on the campus"—Paul signalled out the window—"about a five- or ten-minute walk from here. I decided to walk in there one day to explore and came to this room, and man . . . there was a baby grand piano in there. A Steinway, just sitting there! I was like, *Damn*. It was a Sunday morning. There was nobody around. Not a soul. So I walked in and started playing. I was there for around an hour, then I heard a door close in the distance, so I stopped . . ." Paul had been playing air piano at the table and froze at this point. "I looked around, and for a minute . . . nothing. So I started playing again for another hour, then I left. I went back the following Sunday. Then again the week after that. Around the fourth time, I noticed there was a sign, it had always been there on the wall but I hadn't seen it. It said something like: *Unauthorised use of this piano could result in a $25,000 fine*." Paul let out a burst of laughter as he leaned back in his chair. "Can you believe that?! I got to thinking about it, like wow, what if somebody had caught me? It's just one of those things, I guess."

Paul now had more colour in his cheeks than when we'd arrived at the diner. He got up to use the bathroom. The waiter came by to refill our coffee, assuring us we could stay for as long as we wanted. Upon returning, Paul relaxed into his chair.

"Do you remember the Occupy movement?" he asked. "There was a time when they challenged every homeless population to occupy a park in

every major city in the United States. In about 2012, I think it was. And we did. I was in Tucson, Arizona, at the time. We occupied a park right in the middle of the city. All these homeless people and sleeping bags. Spice was the big drug then. You remember that?"

My first encounter with spice was several years ago, when it had become popular with the homeless communities of central London. I was giving a haircut when the person's head suddenly dropped forward like a dead weight. It was as if he'd been injected with an anaesthetic. I had to keep him from falling. I laid him down and sat there until he began to stir. A joint had been passed to him a few moments before. The smell of spice stuck with me after that.

"It was killing people here too," Paul said. "It still is. People were doing so much of it during the Occupy movement, inside that park. One morning, I woke up—I'm an early riser, so I was usually the first one up. I went over and sat by this pine tree, as I always did. There were some steps that led down to a fountain, and I saw this guy sitting there like this . . ." Paul slumped his body and let his head hang down to his chin. "I lit up a joint and started smoking it and thought, *That dude doesn't look very good, I should go and kick his feet and see if he wants to smoke this with me.* Then this other guy walked over there, a really big guy. He looked down at this dude, then looked up at me. I'll never forget it—he said, 'This guy is dead.' I went over and looked, and sure enough, blood was dripping out of his mouth. He was stiff as a board. He was nineteen years old and gone." Paul shook his head slowly. "He came into camp that night. Nobody had ever seen him before. He drank with the hardest drinker, then smoked some spice. That was it."

Paul and I headed back to the car soon after. Some of Boulder's residents were out walking their dogs, dressed for cold weather. The Corolla was parked beneath a tree that had the brightest red leaves. Before we got in, Paul reached up and picked a leaf from its branch, twisting it around in his fingers for a while, smiling. We drove back toward downtown but took a detour. Paul showed me a few places along the way.

"See that house? I laid the floor in that place. We used some beautiful wood. I'm a carpenter by trade. I told you that, right? Floors, rafters, everything. I still have my tools and do some work here and there, but I had an accident back in 2004, which slowed me down. I work when I can."

Paul parked outside a grocery store and stopped the car. "I signed up for a job at that store earlier this week. They already called me back, so I hope I'll be starting next week." He paused, then smiled. "I'll get myself another guitar just as soon as I have the money, and I'll be out on the street playing again in no time."

Paul and I speak on the phone from time to time. As of this writing, he is still living out of his car in Boulder, but has been working a few different jobs recently with plans to buy an old-school bus to renovate and live in. In the two days we spent together, Paul gave me a lot. His honesty was refreshing. He had lived a life and didn't try to sugarcoat his shortcomings, or hide the things that made him feel alive. There was no haircut, no offering, just two people who trusted each other's intentions. For what it's worth, I cherish that.

San Francisco

Yoel

I LANDED IN SAN FRANCISCO UNINSPIRED AND FRUSTRATED. It was the last stop on a two-month trip to America that had left me feeling empty. The year before, my friend Hal Samples and I had spent some time immersing ourselves in the city. It was winter and the days were shorter, but we wandered the streets for hours and hours, our days bookmarked by the encounters we had with new people. They seemed to steer us in the right direction, somehow.

To briefly touch on the homeless population in San Francisco: it's staggering and can be found almost everywhere, especially concentrated in the districts surrounding downtown, such as Tenderloin. Walking through areas like this can be overwhelming. There's an energy that's almost impossible to ignore. The pain is palpable, even without the context and complexity of someone's story.

On this day, I got the metro to the Mission District. The colours and sounds of this neighbourhood are unmistakable. The sky was all blue; it seemed to make the street murals and storefronts more vibrant than I remembered. I walked a few blocks before stopping for coffee and sitting on a bench outside. As I reached for my bag and made to leave, I heard a voice and looked up.

"Hey, man, you got a light?" he asked me, then introduced himself as Yoel. He was wearing a bright-orange work shirt with a pen in his top pocket. I didn't have a lighter, but there was somebody smoking behind us. Yoel sat down next to me. I asked him what he'd been up to that morning and we began talking.

"I've been at work this morning. There's an agency a few blocks over that way." He pointed his cigarette in the direction from which he'd come, while his other hand shielded his eyes from the sun. "Lots of people turn

up to that place, but if you get there early there's a good chance to get a construction job for the day. Sometimes you're lucky, sometimes you're not. But I keep going. I've gotta get myself back on my feet." He sucked in more of his cigarette, tapped the butt and watched as the ash blew to the curb in front of us. "This isn't my home. I came here from Miami around one month ago. My life is all back there."

Yoel paused and shook his head, chuckling in disbelief. "It's crazy how things change so quickly . . . I was married for a long time, but it came to an end. I have children but they've all grown up now. I never thought of coming to San Francisco. I met this girl and we started to see each other more often. When she said she was moving back to the West Coast, I decided to follow. It felt real and love can make you do strange things. I left everything when I came here."

Yoel's relationship ended within weeks of his arrival. They were living in a room together until they had an argument one day.

"We were both stressed. I think I already knew that I'd made a mistake . . . She could sense that. I didn't know anybody in this city. When I left that day, I booked myself into a hotel for a week until I ran out of money. The next evening, I was walking around with my things and ended up at Mission Dolores Park. I stayed there for the first night, and I've slept in the same place since."

I wanted to spend more time with Yoel, so I asked him if he'd be interested in a haircut.

"What?! Do you mean right here on the street? Yes, sir! Let's do it."

We got started.

"This is the first time I've been homeless in my life, man. You want me to tell you something funny? You won't believe me, but when I was a kid in Alamar, Cuba, me and my friend Luis went to sleep on the street. Just to see what it was like. I remember laughing so hard one time when he grabbed some cardboard that smelled so badly of fish!" Yoel let out a loud laugh before his smile faded. "But it was cold out there, man. We only lasted for five days until we ran home to our parents. I started thinking about those times on the first night I stayed outside in the park here in San Francisco. It's been pretty tough. For the first two days, I kept all my things with me. I wanted to pay for a locker to keep them safe, but I didn't have enough money. After a few days, I wanted to find somewhere to

shower. I left my bag with someone in the park. When I came back, the police were there, and they had taken it. The worst part was that I could still see it. I called out and said, 'Hey, that's my stuff right there!' I could see my bag behind them on a truck, but they wouldn't let me take it . . ."

I felt for Yoel. Shame seeped from his words as if he'd brought this all on himself.

"Man, that hit me hard . . . All my belongings were in there. The police didn't care about any of that. Somebody said to me afterward that I should have been given a ticket to pick up my things somewhere, but nobody told me what to do. I called one of my friends in Florida the next day and told her I was in a tough spot. I have my car and my tools at her house still, so she's going to try and sell them for me. But I couldn't be truly honest with her. I'm embarrassed. How can I say that I'm living on the street? I first arrived in Miami in 1994. I started working on construction sites, doing whatever I could to make some quick cash. I found a company that paid well, and over the years I worked my way up. I earned enough to bring my parents over to the US in 1998. That was a really nice moment, even if my brother and sister in Cuba still hate me for that." Yoel grinned.

We talked until the sun was low. Yoel had a cheap cell phone he'd bought a few days before, so we swapped numbers before parting ways.

It was my last night in San Francisco and I was leaving for LA early the next morning. After meeting Yoel, I'd written something and posted it on my Instagram. I received a message that changed the course of the evening:

> Hi Joshua, I've been following you for a while and I saw your post about Yoel, it really touched me. I'd love to help somehow . . . I don't know if this would be possible but I'd love to send him some money if I can? It's not life changing but I have $500 I could give. Let me know what you think. Thank you!! Alexandra

I'd checked in with Yoel on the phone earlier that day. He was in good spirits, telling me that he'd been back to the job agency and got another day of work, along with compliments on his new haircut. I wrote a grateful reply to Alexandra and sent her my bank details to make a transfer.

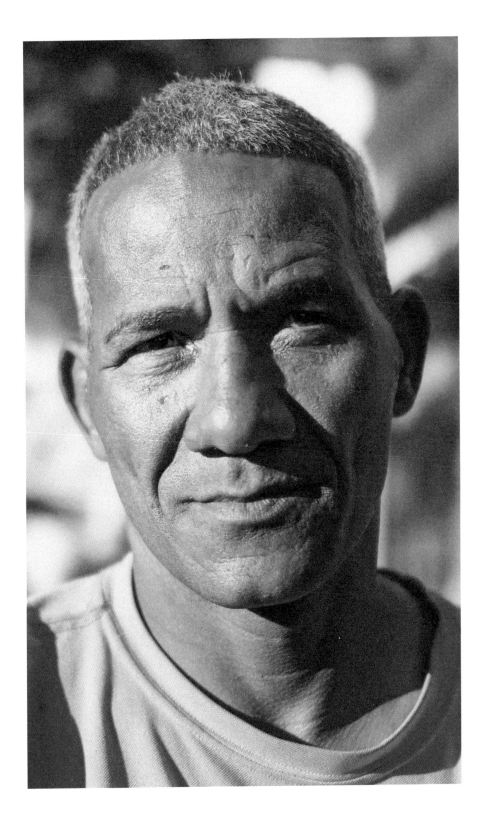

I called Yoel back and asked if he could meet me in the same place as before.

It was around nine p.m. when I got off the bus. I spotted a tall figure across the street, bundled up in a dark-green hoodie, holding a steaming cup of coffee. I knew right away that it was Yoel. We hugged and spoke for a bit. I hadn't mentioned the money yet. I made up some excuse to go to a nearby deli. Inside, standing at the back by the fridges, I told him about the message and explained what had happened. I passed Yoel the cash in a clumsy handshake, like I was tipping a waiter. When I said it was five hundred dollars, he was taken aback, and his face changed suddenly.

"No, man, what do you mean? That's too much money. I can't take that. I don't—"

I interrupted with all the reasons I could think of as to why he should take the money. He listened.

"Seriously?! You don't know how much this will help. Damn, I'm happy right now, this is good news!" There were tears in his eyes. "This will give me some breathing room. Please . . . you have to say a huge thank you to Alexandra."

I knew this wouldn't change the basic script, but it was a boost. Yoel wore his regrets on his sleeve so everyone could see them, and was doing all he could to change his situation.

A week later, I phoned Yoel on my way to LAX, before flying home to London. I wanted to see how he was and tell him I'd keep in touch. He shared the latest.

"Things have been good, really . . . I booked myself into a cheap place with that money. Just being inside the last week has given me energy. I have work for a few days at the construction agency. I'm figuring things out. Of course, we have to keep talking! I was really happy to meet you, man. Call me whenever. Next time, who knows where I'll be."

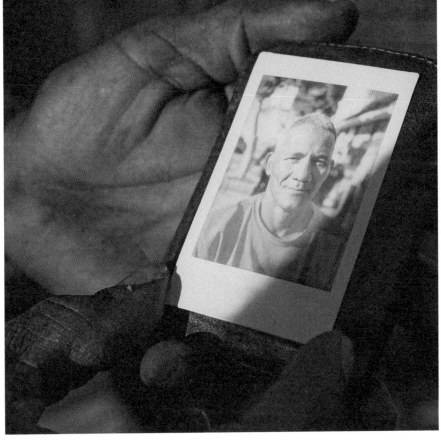

Los Angeles

Adam, Tiffany & Brandon

IN THE SPRING OF 2019, WHILE VISITING A FRIEND IN LA, I met a family who were living in a tent in Skid Row. Their dedication to one another was truly humbling.

My buddy Paul Avila invited me to join the distribution efforts of his community group, Pauly's Project, which provides everything from food to essential sanitary products to LA's homeless community. The project was named after and inspired by his son Pauly, who is blind and autistic. Seeing the boy's love for music—how it calmed and grounded him when things got tough—Paul started giving out headsets to people living on the streets in Skid Row, and things took off from there.

Volunteers at Pauly's Project meet in the carpark of Farmer Boys, a restaurant on South Alameda Street. It's inspiring to see who turns up and commits their Sunday afternoon to spend time with some of the most dehumanised people in LA—from teenagers to elderly couples to mums with young children. People flock here from every corner of LA County.

The volunteers typically make multiple stops throughout the day, unloading foldout tables from their cars to create lines of items that anyone can collect from. On this day, there were boxes of pizza from one car, folded clothes from the next, sanitary products and bottles of water from another—and one of the most sought-after commodities in Skid Row: blue tarpaulin. It was really something to witness the friendship between long-term volunteers and those who called these forgotten streets their home. That doesn't happen overnight; it takes time and dedication to build that trust.

On one of our last stops of the day, I noticed a few tents in an underpass, sitting in the shadow of a busy highway. I walked over to a grey and red tent that looked tall enough to stand up in, and, not seeing anyone

around, I called out. The zipper opened and a man popped his head out to greet me.

"Hey, how are you? I've got some things here that might be useful," I said, showing the care packages in my hands. "There's a bunch of other stuff down there by the cars." I signalled down the street to the rest of the crew. "There's even some pizza left, I think."

"Pizza!" a child's voice shouted, and out came a boy who must have been about ten years old. "I want pizza, Dad! Can we go get some?"

"Sure we can," the man said. "Thanks. We'll come over and take a look."

"Great. I'm Joshua, by the way."

"I'm Adam, this here is Brandon, and back there . . ." Adam unzipped his tent slightly more. "That's Tiffany." I peered in and saw a woman sitting on a bed with her legs tucked underneath her, wearing a grey hoodie and a black turban. She smiled and waved at me. I knew I'd be leaving shortly, so I asked if it would be all right to come back and visit them again the following day.

"For sure!" Tiffany said. "Come by and see us. We'll be here."

As I drove downtown, it dawned on me that I'd forgotten to take the name of the family's street, so I retraced my route from the day before until I found their spot. I called their names, then heard some rustling, then Adam's voice.

"Hey, it sounds like the British dude is back," he said in his Southern accent before emerging from the tent and greeting me with a handshake. "What's up, man? How are you? You wanna come inside?"

I stepped through the entrance, careful not to knock my head on the camping light hanging overhead. It was another world in there. This wasn't just a tent; it was their home. The space was easily large enough to sleep eight to ten people, but they had arranged things to construct three different sections, each its own small room. The majority of the floor was raised slightly, creating two different levels. I was standing by the door where tarpaulin stretched out beneath my feet and pairs of shoes were organised at the entrance. A few gallon bottles of water stood next to them. In front of me was their living area where a lengthy sofa looked over a seemingly antique rug. There were two small fold-up tables hold-

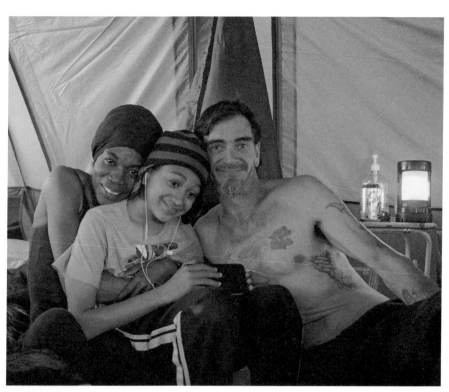

ing books, a bottle of hand sanitiser and a phone plugged into a charger. I followed the cable from the phone down to an extension cord beneath the tables. They had power, which certainly isn't run-of-the-mill for tents in that area. On my left stood a double sleeping area, for Adam and Tiffany. On my right, at the far end of the tent, was Brandon's room. The sofa created a division that gave some privacy. Bric-a-brac covered the edges of the space, but everything was tidy and organised.

Tiffany was sitting on the bed as she had been the day before. "Hey! Come on in. Have a seat." She smiled widely and pulled out a stool for me.

They were warm hosts from the start. Adam offered me a drink and Brandon, who wore headphones while playing a game on his phone, came to sit on the bed next to his mum. I was grateful that they had let me into their home. It was clear that Adam and Tiffany had cultivated an atmosphere of love and strong morals for their son—but of course, the vulnerabilities of living tucked under a highway, with only a thin sheet of plastic between them and the outside world, was hard to ignore. They, of course, were aware of that fact more than anyone.

"It's not because we're ashamed that we're homeless," Adam said, "or that we live in a tent. It's just that I keep my circle very small."

"That makes a lot of sense," I responded. "I think I'd feel the same. Is there a lot of foot traffic through here?"

"Hmm, not as much as other parts of this neighbourhood. That's the good thing about being slightly farther away from Downtown. I've managed to rig us up with some power here too, which makes a huge difference."

"I can imagine. I'm happy I came over to your tent yesterday with the Pauly's Project guys."

"Well us too," Tiffany said. "Yeah, they come around here pretty often. I think we've met Paul's son before. It's good that people like that come by to help out."

"It's beautiful in here, by the way," I said. "You've done so much to this space."

"Thanks, man!" Adam replied. "Feel free to have a look around."

"Can I show you my room?" Brandon asked.

"Sure! I'd love that."

We moved to the area behind the sofa and Brandon gave me a tour

of his side of the tent. His bed looked like that of any other child his age: colourful sheets, a small army of cuddly toys, a book next to his bed, a box of games on the floor.

"Wow, come on, you've got it going on in here! I really dig your room," I said, as I looked through some of Brandon's things.

"Thanks! It's pretty cool, huh? I had it differently before, but my dad and I changed things around a bit recently. It's better now."

"For a long time, the tent was really tiny," Adam explained. "It was as big as that bed there. All three of us were crammed in. Then we spent our money to get this one, it's brand new. See, we was tryin' to get into apartments, we was tryin' to get into Section 8 housing, we was tryin' to get into hotel rooms—hotel rooms are more expensive than goddamn apartments, and apartments are off the chain here . . ."

I had my camera by my side. I saw Brandon looking at it curiously, so I asked if he'd like to use it.

"Yeah! How do I do it?"

Once I'd shown him, he hit *Record* and began to point it around the room, then at his mother, who smiled, before focusing on me and Adam as we continued talking.

"Before this," Adam said, "we were staying at a friend of Tiffany's— actually, it's a friend of her mom's—they allowed Brandon and Tiffany to stay there for a while, so they had a roof over their head. But eventually that came to an end, like most things do." He took out an ashtray and lit a cigarette. "Me and Mama," he went on, referring to Tiffany, "we both had jobs; she was doing her thing and had two jobs lined up. I worked through an agency—Select Staffing—it's a temp-job place, they place you all over. They sent me out to Western Mixers, which is a nut factory, and I did that for about two and a half months until the season was done. Now I'm waiting for them to open back up and do it again."

"Were you born here in Los Angeles?" I asked Tiffany.

"Yeah, I'm from here, but I left for a long time. I still have some family, but it's complicated. One of my brothers passed away in 2006. I have a younger brother and a sister too, but we kind of grew up differently. I was always an outcast . . . a total outcast. I didn't really have many friends, and the friends I did have . . . they ended up not being such good friends. I was just different."

"People were always telling her to be something she's not, rather than just being herself . . ." Adam interjected.

"I hated junior high school," Tiffany said. "Even when I was young, I was already looking for a way out . . . Sometimes I feel like I was born in the wrong decade, you know? I left home when I was like . . . sixteen, and moved over to Hollywood. I started meeting people from around the world, so I didn't feel so bad. I met a bunch of outcasts, from everywhere. I tried my hand at acting for a while, but it wasn't to be. They told me I was too short . . . Religion and music became my art after that." I noticed some Jewish candles next to the bed. "I did *not* like the hip-hop lifestyle though, there was too much debauchery. I didn't express myself that way. I mean yeah, I smoked a little weed and drank a bit, but I always thought of myself too badass to go in for the hard drugs. It's even been twenty years since I smoked a cigarette . . ."

"Now I smoke them for her!" Adam said with a loud laugh.

Tiffany rolled her eyes. "No matter how stressed I get, they could be sitting right there in front of me and I won't pick one up. They didn't go with my image," she said with a grin.

Brandon had gotten the hang of my camera now, zooming in and out, checking the screen as he recorded his mother.

"Then an opportunity presented itself in Arizona in 2004, which I jumped on because, with the job market here in LA, I just wasn't making it. I was doing odd jobs to make money, but that was a chance to start studying again, so I did that for a while."

"Is that where you two met? In Arizona?"

"Yeah, it was. But we've been all over, haven't we?"

"Yep," Adam said. "We had an RV for some time, but we had to let that go. We've been all over . . . I'm from Pennsylvania originally, but I moved to Louisiana when I was just a boy."

It felt like the right time to see if anyone was keen on getting a haircut. I asked them.

"What?!" Adam exclaimed. "Hell yeah, man. You a barber? You kept that quiet until now!"

"What about you, Brandon?" Tiffany said. "Maybe you'd like Josh to cut your hair too?"

Brandon took off his hat, revealing short, curly brown hair. "Hmm . . .

I dunno. Actually, I think I'm okay . . . Unless you can give me straight hair?"

"You don't want straight hair, Brandon," Tiffany responded quickly. "If God wanted you to have straight hair, He would have given you straight hair. God didn't give me straight hair."

"I know, I know. I don't care about it, really." He gave a cheeky smile and looked down at the floor.

"Good," Tiffany said affectionately, "because you've got people with straight hair wanting curly hair also. I used to work in a salon for a while, and believe me, everyone wants to be something else. I even had someone once say to me, 'I want to be darker like you,' and I was like, 'Oh . . . okay . . . and you're ready for the oppression that comes with that?'"

I began unpacking my things, one by one, until I took out my empty spray bottle. "Would you mind if I fill this up with water?" I asked Tiffany, as Adam was setting up a chair for himself.

"Of course!" She took the bottle and went to the corner of the tent where the water was. Adam unzipped the door so that we could look out at the street while I cut his hair. I was interested in his opinion on LA beyond the fifty-block radius that makes up Skid Row.

"So, how is it for you, living here in LA, Adam? I mean . . . beyond your spot?"

"LA's one crazy place, man . . . You've got people running around forgetting why they want all the money they're chasing. Don't get me wrong, money is not the problem. It's knowing where your happiness lies. Like, I've been happy as shit before when I've been broke as fuck."

"What makes you happy, mate?"

"What makes me the happiest is that I've got a woman who stands beside me, no matter what's going on." I glanced back at Tiffany; her eyes were fixed on Adam and she nodded. "We have a kid who respects us, who strives hard and wants to learn. He's well educated. That's what makes me the happiest. See, it's not about the money. It's the fact that you're never satisfied. It's never enough. So, you own a fifteen-million-dollar condo now? When is it enough? It will never be enough on that road. See, the problem isn't the rich, or the poor, it's the mentality of both sides. The mentality of the wealthy is that they look down on the poor, because they haven't got a hundred-dollar bill to wipe their ass with."

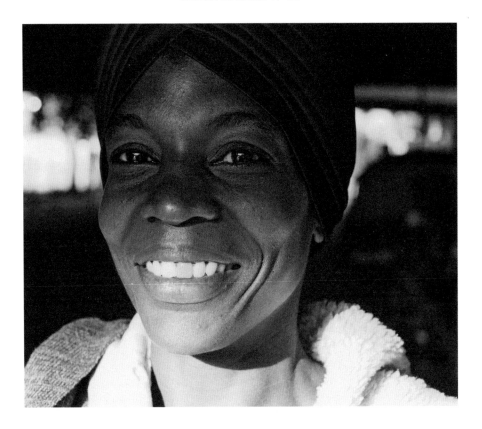

"Benjamin Franklin wouldn't like that much either," I joked.

"That's true. Like, I can see it from both sides . . . You think I wanna be down here with the stragglers and the junkies? But I'm not gonna judge them for what they do. I'll tell them when they're wrong, but I'm not gonna judge them. Why? Because we all make our own mistakes. I'll let them make those mistakes and hopefully they grow from them. I had to learn to grow from mine. I'm sure you had to learn and grow from yours."

"I make mistakes too," Brandon said from behind the camera. "Like . . . falling off my bike." We all laughed. "Or . . . in my math homework."

"So, maths isn't your favourite subject then, Brandon?" I asked.

"Nope, it's science. I like that you can build things out of chemicals."

"You do like science, don't you?" Adam said. "We go to the library together. We used to go more when we lived closer. But we still try and go after Brandon has school. We'll go and get some books, get something to eat, then come back home and have some quality family time."

"You guys keep a pretty good routine, huh?" I commented.

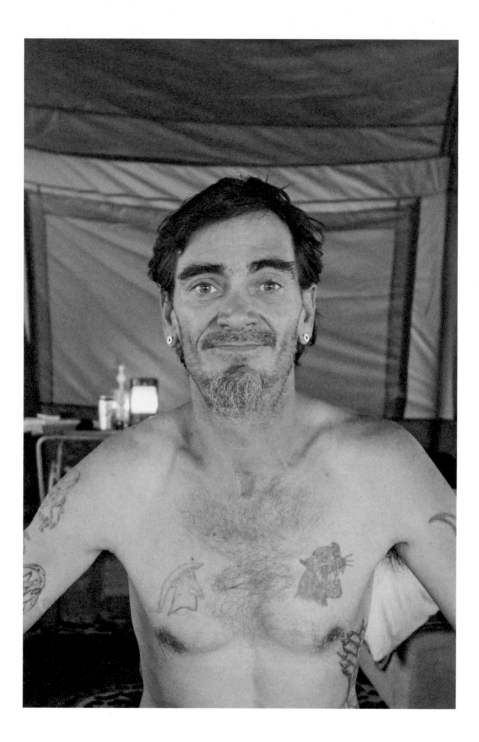

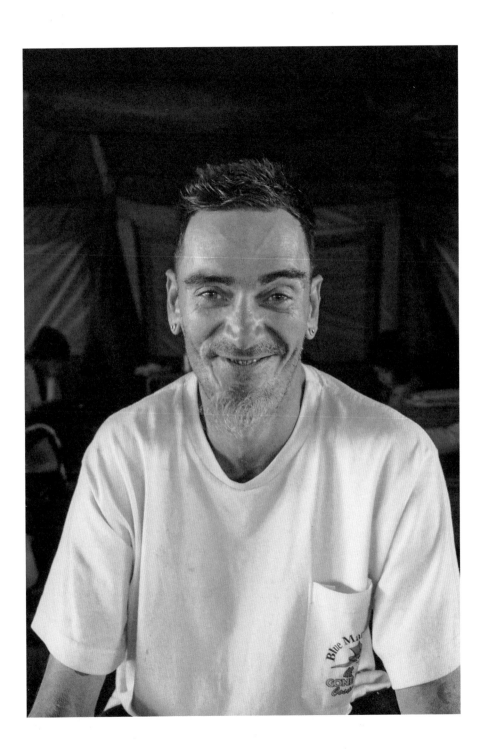

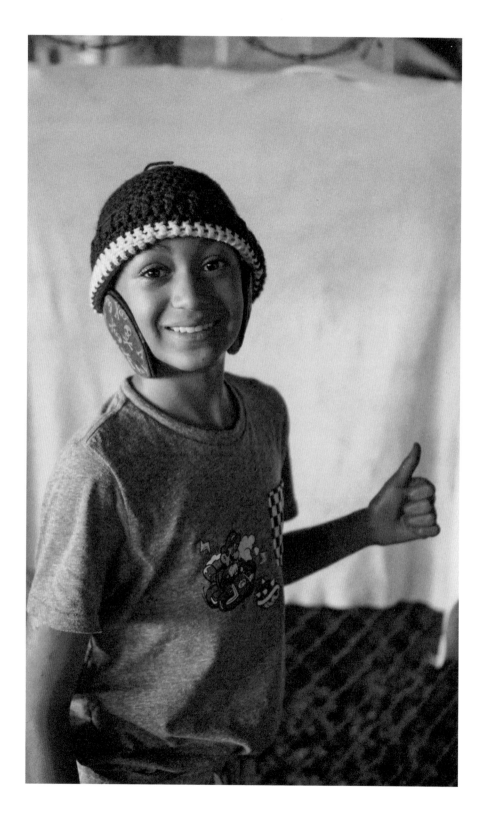

"Oh yeah, we gotta keep that routine going," Tiffany said. "Certain times are dinner. Certain times are homework. Certain times are bedtime."

"That's right," Adam continued. "We keep those on point. So that way, when he gets older, he'll know how to manage his life . . . because if you learn to manage your time, you can learn how to manage everything. It takes a minute to get used to that routine. Now at night, when it's time for bed, all I gotta do is say, 'Hey, buddy, it's nine p.m.,' and he'll shut his phone down, come and give us some love, and go to bed, no problems."

"Yeah, no problem at all," Brandon chimed in with a humorous eye roll.

"Brandon is such a sweet kid," I said, quietly enough so Brandon couldn't hear me.

"He is my heart, man. You gotta give what you wanna receive. That's why we teach him that you being respectable is going to have people look at you in a different light, and we get it all the time—'Your kid is so respectable, he's so well mannered.' It's been rough, but it'll also get better. Life don't always work out the way you want, so you gotta be thankful for what you've got."

I handed Adam the mirror shortly after.

"Hell yeah, that looks good, man!" he said as he held it out in front of him. "You got some good art, man, good talent." Tiffany was outside the tent now, smiling and snapping some photos of Adam on her phone. "I keep on looking at it and feeling it and fondling it . . . You know, I've gotta make sure it looks good for her." He winked at Tiffany.

After his haircut, Adam and I took a stroll down the street and spoke more. I told him that he had a beautiful family and thanked him for letting me be part of it for the day.

"It could be a lot worse . . . you know what I mean? I could be on the goddamn street with no pillow, no blanket, no family, nobody to give a shit if I die . . . It could be so much worse. As long as you've got just one person in there to help you, to let you know that you're worth something, it's worth keeping your head above water. And that's what they do for me. Just being in their presence lets me know that I'm worth something and I'm worth being loved . . . and that I've got something worth giving back to them. They love me and I love them to death."

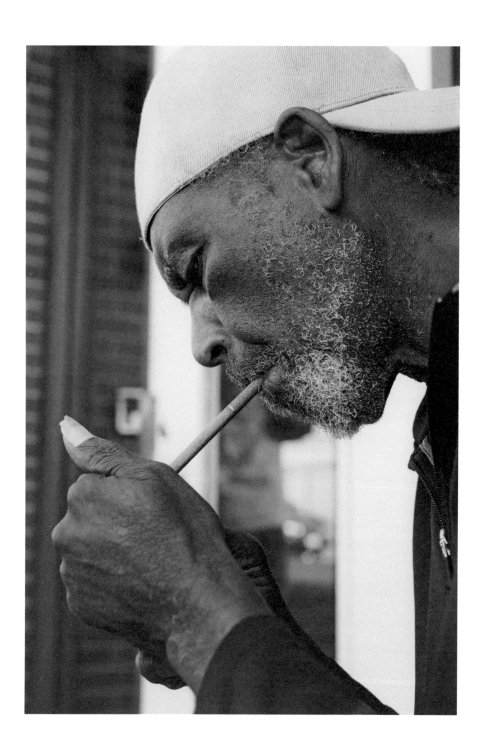

Larry

LARRY WAS SITTING ON A MILK CRATE outside his building on Crocker Street, in Skid Row, when Jamie Morrison and I turned up. Standing next to him was a man named Derrick, who worked in a mission building nearby. It was March 2018, and we were a few weeks from our first Light & Noise art exhibition, taking place two blocks away. Jamie is a visual artist and a longtime friend. We'd planned this trip together a few months prior, with the intention of building connections with people living on the streets, and for Jamie to create paintings of those we'd meet. As we walked down the street, Larry looked up from his cigarette and we caught eyes. I don't think Larry and Derrick knew what to make of us at first. Our accents obviously indicated that we weren't local. I imagine they thought we'd taken a wrong turn from Downtown, that we were lost and searching for directions.

"Are you guys looking for something?" Derrick asked.

"No, umm . . ." I began. "We're just walking around, checking out the area and talking to people. There's a place a couple of blocks away where we're putting on an event at the end of the month, and we wanted to invite people along."

Jamie talked about the exhibition and our plan to bring some artists together, which got Larry's attention.

"I do a bit of art myself," he said, nodding his head gently and gazing down at his sneakers. "I have my sketchbook, I use that mostly these days. I haven't painted anything for a while. There ain't much space up there anyway." Larry pointed over his shoulder at the glass doors behind him. Through our reflection, I could just make out the small hatch inside, monitored by someone sitting down.

"Okay, so you guys are here to put on an art show . . . What's the pur-

pose?" Derrick asked.

It was tricky to talk about proof of concept before we'd even begun, but I did my best to explain that we wanted to amplify the lives of people experiencing homelessness, and raise money to donate to local organisations.

"I see . . ." He seemed to warm up to us slightly. "Have you been to the Midnight Mission, over on 5th?"

"No, not yet," I replied.

"Well, you should go and see them. It's good you're going around and actually speaking to people. If you give a person your time, you cannot buy it back. You cannot spend a trillion dollars a day to buy back a moment in time. It's the most valuable gift you have to give anyone. If you want to give something to a community, give your time. Give *yourself*."

We asked Larry if he'd like to join the exhibition. He said yes, and so began our friendship.

I visited Larry a few times in the weeks that followed. He'd shown us some photos of his drawings and some larger pieces that he could dig out for the exhibition. I went up to his room one day to see. Getting into his building was as intimidating as it looked. I tried to reach him on the phone, but he wasn't answering, so I used the buzzer at the door. The man minding the hatch got up from his chair.

"You can't come in here . . . Who do you know who lives here?"

"Larry Evans," I said sheepishly.

"What room number does he live in?"

"Umm . . . I don't know."

"Do you have a California ID?"

"No." I'd missed each penalty kick, so I had to dig deep. "I met Larry right here at the door. He sits on that crate and smokes. I can't get hold of him right now. I'm only in town from London for a little while. We're friends, and I'd really hate to miss him."

He looked back and paused for a moment before gesturing for me to enter. "Number 314 . . . that's his room."

The corridors were noisy with voices echoing in every direction. I found Larry's room and knocked. He seemed weary when he answered, but was excited that I'd turned up. His room was humble, a four-by-four-

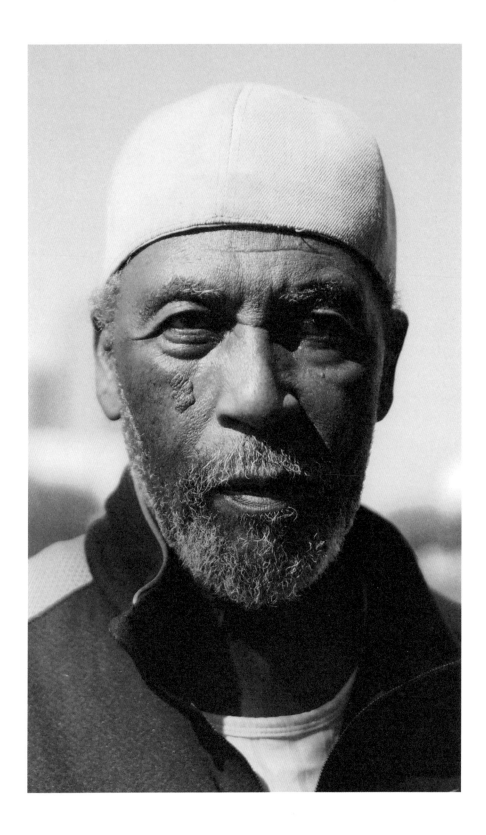

metre box with a sink on one side. He took me through his work and some of the people featured within and spoke to me about his family and growing up in another time.

"When did you first start doing this, Larry?" I asked as he flicked through some brightly coloured prints and paintings.

"Hmm . . . When I was about five years old. I remember one day I was drawing underneath a tree in my grandma's backyard in West Palm Beach, Florida—that's where I grew up—and she came over like, 'Wow, Larry. You've got a gift. This is great, you've gotta keep it up!' Then she reached into her pocket and grabbed me a quarter. I didn't fully pursue it then . . . I was wild and free growing up in the South. My grandma would ask me to go out and get coconuts and mangoes, right off the trees. She was like my big mama, you know? You've got your mama, then your *big* mama who oversees everything. Oh, she could give us a good ass whoopin' too, that's for sure!" Larry chuckled. "She'd always teach us right. I was there until I was about nine, before my family moved out to California. My grandma stayed in West Palm until she passed. That was the last time I saw her before we moved away."

"What about in school, did you take art classes then?" I asked.

"Well, when I was in elementary school, there was this competition in California where they'd send you a picture in the mail, a landscape or something for you to draw, and then you'd submit it back to the company. I did that just for the hell of it one day and I won. I couldn't believe it . . . You know, it wasn't all that much, but they sent me some art supplies and some other art stuff, which was cool. Then in junior high, I won an art summer scholarship. I must have been twelve . . . or thirteen, maybe. So that's where my confidence started to grow. Then I took art classes in high school, but when I finished school things changed a bit for me. I was an athlete by then, I wanted to play pro ball, so I became less concerned with art. But see, my mother, she stayed on my ass, making sure I didn't forget it—'Boy, you better not forget your art! It's your gift.'"

Larry's pace of conversation is always relaxed. Sometimes there are long periods when I have no idea what he's thinking, then he'll let it all show at once. Larry personifies the strong, sensitive type. Tough enough to walk the streets of Skid Row each day without hassle, but caring enough to welcome a stranger into his room and share stories of his past.

"After school, I started playing ball for a Canadian team called the Montreal Expos. I played with them for three years until I got hurt. I enjoyed that period of time . . . Mom was a makeup artist and hairstylist. She'd do that for the movies sometimes, and come home with these big four-by-five photographs of movie stars that she worked with and be like, 'Larry, I got something for ya. This is such and such, you should do a portrait of them. Actually, I already told them you're gonna do it.' And I'd be like, 'Mom, you're putting me on the spot here!'" Larry used a loud, animated voice as he replayed their conversation. "My mom was a great woman. That's what kind of person she was. She believed in people's passions. She became good friends with Eartha Kitt and helped out at the Kittsville Youth Foundation. My sister, Wanda-Lee, has done a lot there too, especially since Mom passed on."

Eartha Kitt was an American singer, actress and dancer, famous for her distinctive style and the novelty song "Santa Baby". She was also an activist, having set up the Kittsville Youth Foundation Dance & Cultural Arts Program in response to the utter frustration, hopelessness and anger that remained in the Watts neighbourhood after the 1965 riots. I was inspired to hear about the foundation, as well as Larry's family and their involvement.

"I used to take my paintings into that studio where they ran classes, for people to look at. Eartha got a lot of my pictures, man. She used to take them from me, saying, 'I like this one, Larry. I want this one . . .' I was like, 'Okay, Eartha, it's yours.'" Larry laughed and rolled his eyes. "I don't know where they are now, but they're somewhere . . . We were like family. I would house-sit for her from time to time while she was on the road touring. Eartha was in and out of LA all the time. When she was in town, she'd invite us over for pool parties at her house, but after a while she started to go overseas more often, and then she decided to move back to the East Coast before she passed."

I was engrossed in Larry's words and journey. When he stopped to roll up a cigarette and make us something to drink, I was gradually transported back into the four walls around us, hugging piles of Larry's belongings tightly within them, which prompted me to ask, "How long have you been living here, Larry?"

"I've been here about nine years. Longer than I wanted. I first came

here in 2010. When I came here, I was homeless. Before that, I was living in the Valley for close to a year, in and out of hotels and motels. I got tired of that. I got reconnected to people who know me and was told about this place. It was rough at first, because I had to wait about six or seven months until a spot became available . . ."

"Is that how long it takes?"

"Yep, it's always a long waiting list."

At the end of that month, we put on the art show and Larry hung his work on the wall. It was his first-ever exhibition. Larry wasn't just part of the event; he was the beating heart of the evening. His sister, Wanda-Lee, came along with some friends and family. It was a pleasure to meet them. On my next trip to LA, I met up with the two of them for dinner and listened to more tales of the Kittsville Foundation and Watts.

There are all kinds of people who use creativity in many ways, to express themselves during their short time on Earth. Some paint constellations across the skies of our mind, and others sit outside their doorway, smoking cigarettes with a sketchbook at their side. I have a huge amount of love, respect and admiration for Larry. I'm thankful he opened up to me and Jamie that day, when we showed up unannounced, looking to talk.

"There's no mistakes when I'm making art," he said. "It's kind of hard for me to explain . . . The best way for me to describe it is—I pick a starting point, and from that point I let it flow. Other things start to develop and so on. I've done some pieces where faces appear from nothing. I look back at the pad and there are faces that I didn't even see before. Mostly of people that I've loved."

Tijuana

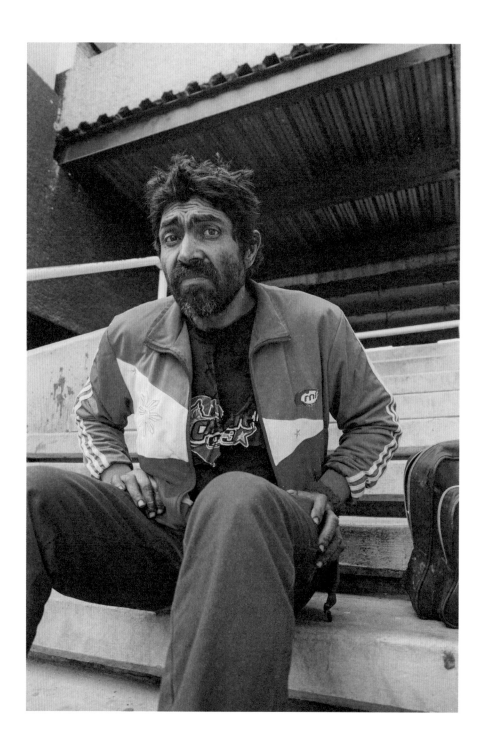

Julio César

A FRIEND DROPPED ME OFF IN SAN YSIDRO, San Diego, immediately north of the US-Mexico border. It was a strange experience, waiting in line to enter Tijuana. While walking across a footbridge raised high above a congested highway, I looked back at America and ahead to Mexico, then at barbed wire that stretched out for miles in either direction. A line so many people risk their lives to cross on a daily basis.

I passed through turnstiles, entered a large air-conditioned space, and reached border control.

"Hello, how are you?" A friendlier welcome than I'd receive at the US border a week later. The immigration officer checked my passport. "*Bienvenido a México.*" He handed it back to me with a smile and I strolled through.

I spent the day getting my bearings. I walked in a loop around the town centre until I ended up close to the border again. It was late in the afternoon by then; the sun shined through a gap in the clouds as I stopped to cross the street. I heard the clatter of a shopping cart, and someone pulled up beside me.

I looked to my left and saw a man with dirt all over his face. A black baseball cap was pulled down low above his bushy eyebrows. The red, white and blue zip-up sports jacket he was wearing had a yellow sun embroidered on the chest. I greeted him in Spanish and asked how his day was going. He clocked my accent and responded in English.

"Hey. I'm good. Where are you from . . . ?" When I told him, he laughed and introduced himself as Julio César. "Damn, you're a long way from home! What brings you to Tijuana?"

I said I'd been in LA and was visiting for a few days for a change of scenery. We crossed the road together. "What's in the cart?" I asked.

"Oh, everything. I find good prices and I sell stuff. That's how I make some money. I'm gonna go see a guy later this evening. He's in a wheelchair and needs some help with a ramp because he doesn't have one. He's been having trouble getting around."

"That's cool you're going to help him. Is he your friend?" I asked.

"Hmm, not really . . . I don't know why, but I made it my business to help him."

"Do people help each other out much here?"

"Here? No . . . not really. It's hard . . . because you know, out here in Tijuana, everybody needs to fight for their own. Nobody has much else to help people that they don't know. But we know all the places you can go to get help on the streets. There are shelters. Some are free, others you have to pay twenty pesos . . . it's not too much. And then there's the Padre Chava over there." Julio took one hand off his shopping cart and pointed in the distance. "They give you a blanket and a little place to stay if you need, and a big breakfast. But I think that some people . . . they are just too tired to help. They don't believe in second . . . chances."

"Do you believe in second chances?"

Julio paused for a second then laughed. "More than that!"

We came up to a little plaza, which seemed as good a place as any to ask if he wanted his hair cut. Kids were running and playing around palm trees and a small patch of grass. Their voices echoed, blending into the sound of an accordion flowing from the speakers of a nearby store. We sat down on some steps, just next to a painted sign reading, *This Way to the US Border*. I unpacked my clippers and comb, and Julio told me his story.

"I lived in Los Angeles before I was deported. That was six years ago. I was born in Tijuana and moved to Mexicali with my mother when I was younger. I went to school there until I was around twelve or thirteen. Then my grandmother took me to a small town in the south of Mexico where my uncle lived too; he built houses around that area. I began helping him with that. We even helped build this big mansion once, by the sea. Man, that was crazy. My uncle died a few months back. I last saw him about four years ago in Guadalajara . . . Hey, you want a cigarette, man?"

I declined with a smile.

"No worries," he said. "Most of the barbers in Tijuana are always smoking. I know a lot of people on the streets, that's why I'm always late

everywhere, because I stop and talk with one person, or two, or three, and then I'm late again. But you have to be really careful where you go, or where you stay, or who you socialise with here in Tijuana. But you get to know the right people."

As if on cue, a lady walked down the steps behind us and greeted Julio. They spoke in Spanish for a while before he introduced me.

"This is my friend Selina."

She sat next to us and joined in our conversation.

"So how long ago did you guys meet?" I asked her.

"Oh . . ." She looked at Julio. "Only a few months ago, I think." Selina had an American accent. I assumed she'd been deported too but I didn't ask. She was calm and happy sitting there as Julio and I conversed. I asked Julio how long he'd been living on the streets.

"Six years . . . I used to live out of hotels for a while, not the nice ones."

As I kept cutting, the stairs got busier; people stepped past us carefully. I became aware of just how fine the line is between those deported from the US and those who can move freely across this border. There I was, neither from the US nor Mexico, yet able to travel between the two as I wished. Julio and Selina's lives had been turned upside down since Uncle Sam shut the door on them.

"Would you want to live in America again if you could?" I asked Julio.

"Yeah, I think I would. I had my life there for a while. I like living in LA. I used to go out to the movies and read books and sometimes I'd be walking in the street there and I'd recognise things and be like, 'This is the place it was set.'" Julio's face changed as I shortened his hair and beard and wiped the dirt from his cheeks, unveiling a pretty impressive jawline.

When we finished, I took a Polaroid of Julio and handed it to him. Seeing the developed photo, he became really animated.

"Look! Ha ha, look at the way I'm sitting. This is great."

I suggested meeting for coffee the next day, but neither of them had a phone, so we decided to leave it up to chance.

"If we see each other again, maybe we can have a tea party," Selina said, doing her best British accent.

We cleared the hair from the steps and swept it into a trash can. I wished Julio and Selina well.

Julio César was another man, in another city, wearing dirty clothes

and pushing a shopping cart full of his belongings. His reality might look a million miles from your own, but some fundamental needs remain the same. It was good spending the afternoon with him. It would have been easy to paint my own picture of his life and the decisions that led him to this point, if I hadn't said hello.

Mumbai

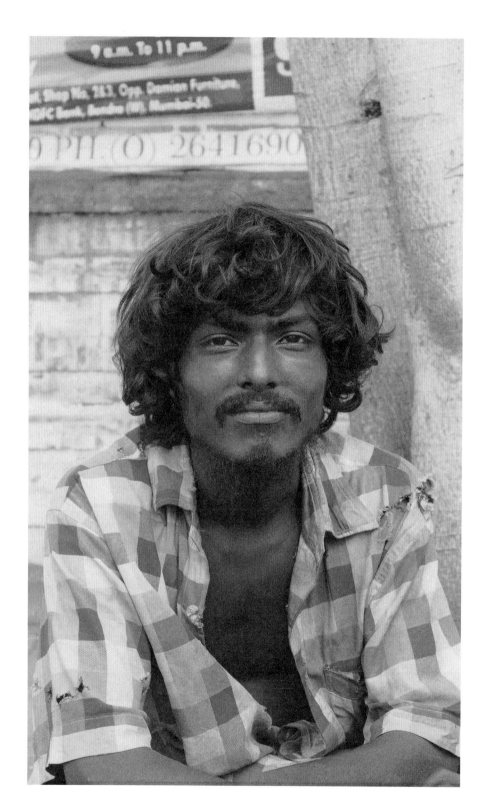

Rashid & Dharit

I WOKE UP AT FIVE THIRTY A.M. AND GOT A TAXI to Madgaon Junction train station, in Goa. I'd been in India for three weeks. Now I was headed to one of the busiest cities on Earth. It was a beautiful morning and the Tejas Express rolled in with its bright-orange exterior glistening in the sun. I took a seat, knowing that in fifteen hours I'd be in Mumbai.

When the train arrived that night, I navigated through herds of people knowing only that somebody named Varun would be waiting for me. Varun had kindly offered to host me in his family's home and be my guide for the week. We had four days together, and the plan was to make no plans, except to wander the streets meeting new people. I'm eternally grateful to his cousin Vanshi for introducing us. A month prior, I'd been in New York City's East Village, cutting hair for a homeless man named Diego, when Vanshi stopped to speak with us. She was from Mumbai. When I mentioned that I'd be travelling there soon, she couldn't have been more helpful, introducing me to Varun via email later that day.

I texted Varun as my train rolled in. He directed me to a café not far from one of the many entrances to the never-ending station building.

"Hey, Joshua!" I turned my head and spotted Varun. A lady stood next to him, beckoning me forward with a big smile. I had arrived in the middle of Diwali, the Festival of Lights, and the streets were bursting with life that evening as I made my way to their house.

The next morning, after coffee, Varun and I headed out of his place. Black-and-yellow rickshaws hurtled past in every direction. A group of people stood on the pavement ahead of us, speaking loudly. As we walked around them, I noticed somebody sitting at the base of a tree. His faraway eyes peered up and almost through us, but a smile appeared. We took that

as a good excuse to sit down and talk with him.

Rashid was from West Bengal in eastern India. As a teenager, he had travelled to Mumbai for more job opportunities. He didn't have anything with him. His blue jeans bore the stains of the streets, as did his sandals, which were falling off his feet. Varun explained to him in Hindi that I'm a hairdresser and that I could cut his hair if he would like me to. Rashid smiled to himself, then nodded slowly. He had tons of hair and said it had been bothering him, what with nowhere to clean it properly. Giving haircuts on the street in India is an experience of its own. Crowds gather like no other country I've visited. One person turned into two, then five, slowly multiplying to around twenty before I handed Rashid the mirror. As I packed up, somebody gave him food wrapped in paper, which he dug into immediately.

Varun and I said goodbye to Rashid and jumped in a rickshaw to head across town.

Later that day, we were walking through some footbridges that connected the street to a busy train station, arching thirty feet above the relentless Mumbai traffic. Some of these corridors seemed forgotten, but for the people who called them home.

We turned a corner and saw a middle-aged man sitting cross-legged on a piece of cardboard. A ragged unbuttoned shirt hung loosely from his shoulders, showing his collarbone and his brown skin that stretched tightly around them. His name was Dhavit, and he was asking for money with little acknowledgement from the few people who passed by.

I thought Dhavit looked too busy hustling to spend time with me and Varun, but I was mistaken. A crowd equalling Rashid's began to gather as I crouched down on that footbridge and tended to Dhavit's hair. At one point, a man approached us and began yelling. He was causing enough of a racket to attract more people to stop and listen. I switched off my clippers and paused for a minute and asked Varun to translate.

"So he's saying . . ." Varun paused, patiently waiting for the next set of words before translating them, "that he doesn't understand why you are doing this for this man. He says that Dhavit does not deserve to be helped because he brings this life on himself, most likely taking drugs and not following the right path."

I took a breath and thought for a second. I'd met this man before.

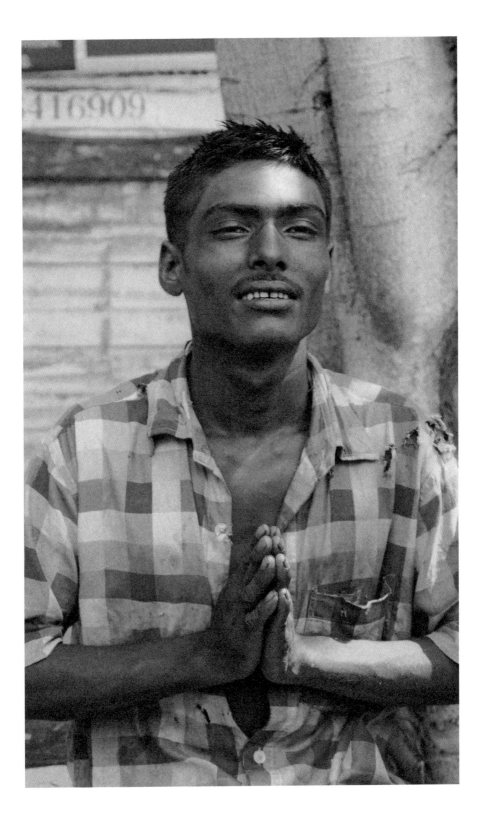

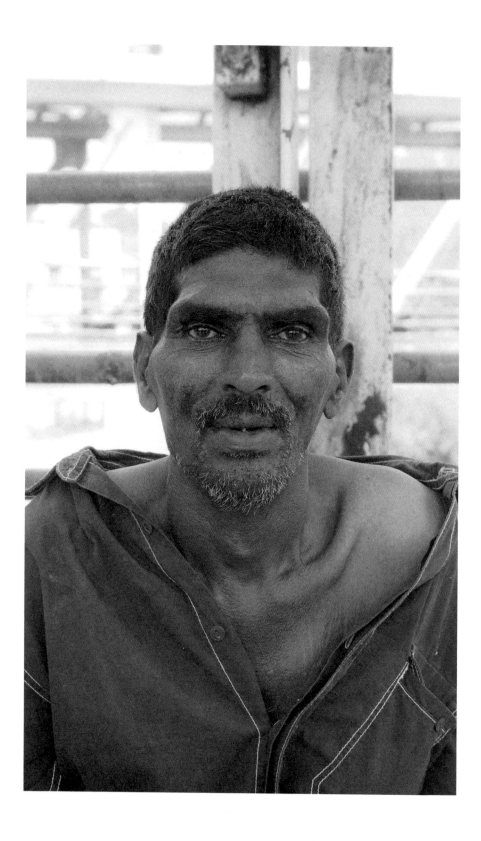

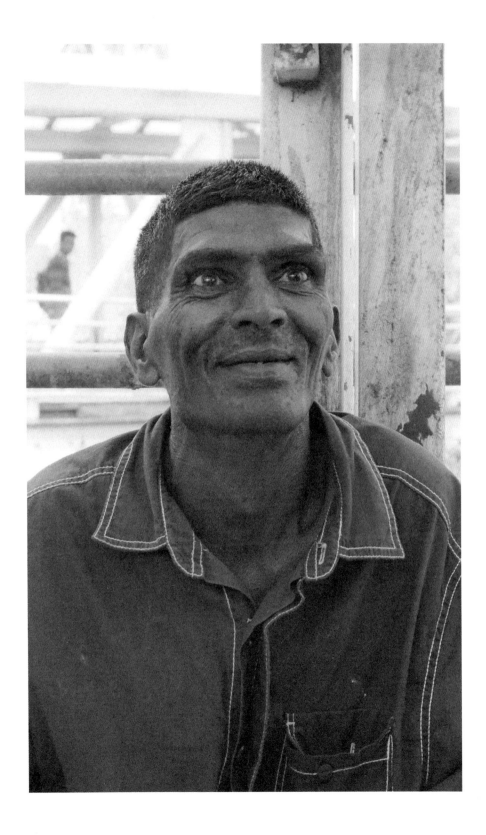

On this occasion, he was wearing a pastel-yellow short-sleeved shirt, with a newspaper folded under his arm, but this school of thought has embodied many people over the years. The question of whether somebody is deserving or undeserving of my time is one I have trouble understanding. I comprehend theoretically: an arbitrary line is drawn, based on my principles of right and wrong, and when a person crosses that line, I should wash my hands of them.

I struggle with this message fundamentally, but even more so when it's given as some kind of guidance to protect me. I know that people lie, tread on other people to get what they need, make mistakes and bad choices. However, I blurred the lines of who "deserves" my time ages ago. I wish to learn about people, not mute them.

At the time, of course, I gave the man a much shorter version. Varun's poor ears had to deal with us both speaking simultaneously, which he coped with like a pro. I removed the gown that I had draped around Dhavit and brushed the hair away from his neck. He wobbled his head graciously, in neither a shake nor a nod, in that uniquely Indian way, to thank me.

That's how things went for the next couple of days in Mumbai. Varun and I darted our way around the city, from north to south, spending time with people who cared to speak with us.

Arnav, Ajay & Govind

VARUN AND I HAD ONE MORE DAY TOGETHER and decided to head farther beyond the city, getting out of our rickshaw near the entrance of some gardens, with a high wall stretching around the perimeter. In the distance, I could see some small colourful huts nestled among the greenery. Varun had a word with a group of security guards at the entrance to suss things out, which led to our impromptu visit to a children's centre inside. We walked for a few minutes until three boys hurtled toward us, full of energy and excitement. One of their mentors came to greet us and kindly gave us a tour. We learned the boys' names— by that point they were tightly gripping our hands and taking us on a tour of their own, dragging us eagerly from one place to the next. Their names were Arnav, Ajay and Govind. I chatted with the man who had greeted us to find out more about the centre.

"Most of the children you see here were unaccompanied and living on the streets of Mumbai. So, we intervene and provide everything we can: protection, education, health care, nutrition, creativity and social skills. Many already mistrust adults. They have often fled conflict or ill-treatment of some kind. We always endeavour to repatriate the children back to families where we can. We're not an orphanage."

I gave as many haircuts as I could that morning on a sun-soaked step in the yard. Last up was Govind. I've thought about him a lot since. I remember him using his finger to trace the tattoos I have on my arm, teaching me the names of the sun, waves and Earth in Hindi. Govind had a scar across his forehead. I wondered how it happened and how long he'd been there. Music poured out of one of the buildings nearby. I glanced around to see the boys brushing and styling each other's hair while dancing. It was hard to peel away from Govind as we said goodbye.

I hope he's growing up with the love and opportunities he deserves. It was clear by their smiles that the centre was doing all it could to provide that.

Varun had been an absolute hero. It wasn't easy saying farewell to my new friend. For giving himself so freely, I will always be grateful.

Priyanka

ON MY LAST DAY IN MUMBAI, I met up with a man named Vasant, who had messaged me on Instagram offering to help. Vasant knew of a street in his neighbourhood where groups of people were living on the pavement next to a busy highway. We spoke to the families sitting outside their makeshift tarpaulin homes. Most had travelled to Mumbai from rural villages in the north, in search of increased job opportunities.

Young children were playing everywhere and ran straight over to say hello. It wasn't long before I was wrapping a gown around a little girl named Priyanka. Her mother instructed me on how much hair to take off while Priyanka moved her head in every direction, playing with the water bottle from my kit, spraying it at other children. It was absolute madness and I loved every minute, but it was difficult to ignore the dark underbelly of her living conditions and how vulnerable girls like Priyanka truly are. A woman told us stories of having to fight away traffickers who come to prey on them at night.

Everybody looks out for one another on a daily basis to make sure nobody goes missing, but tragically it happens. Imagine this reality for a minute: waking up to find one of your children gone, in a city of eighteen million people. It's unbearable to contemplate. I'll hold on to the day Vasant and I spent with the families that lived on that street. In spite of their circumstances, they gave us their trust and radiated love. They had nothing. The main thing they asked for was books so that the children could study.

As I finished cutting, a lady passed me a pink clip to put in Priyanka's hair, which made her smile. Her bright shining eyes looked up at me with no clue as to how vastly different her life is from those of so many other children her age.

Melbourne

Jody, Christine & Luke

I **ARRIVED IN MELBOURNE FROM LONDON** with Jamie Morrison, to put on
an art exhibition with HoMie, a Melbourne-based street-wear com-
pany and social enterprise that supports young people affected by
homelessness and other hardships. We'd partnered with HoMie to create
an Australian instalment of Light & Noise featuring portrait paintings of
men and women experiencing homelessness. We had three weeks until
the night of the show and intended to spend the first of those out on the
streets, getting to know people who would become part of the exhibition.
It was the beginning of December 2019. We flew in on Sunday and went
out for a walk around the city the next day.

Bourke Street runs through the heart of Melbourne's CBD—the cen-
tral business district. It was a clear morning and the streets were already
bustling with shoppers. We reached a set of steps near the entrance of a
large mall and noticed a girl sitting hunched over a plastic cup at her feet.
This was Christine. Jamie and I approached to say hello and told her it was
our first day in town. I asked how long she'd been sitting there.

"I've been here a little while," Christine said. "I'm just trying to get
enough money to sleep somewhere tonight. It's pretty busy, but you'd be
surprised how little people actually stop, or reach into their pockets . . ."
Christine was timid. Her arms were crossed, and her shoulders hunched.
The hoodie she was wearing hung loosely on her tiny frame.

I asked Christine if it was all right for us to sit with her for a bit longer.
Jamie offered to get her something to drink and went to find the nearest
café. I took the opportunity to speak about why we'd come to Melbourne
and the upcoming exhibition. I showed her some of Jamie's paintings on
my phone.

"Wow, that's amazing . . . So, are all of these people homeless?" she

asked. As the minutes passed, Christine seemed more comfortable and our conversation flowed. "Are you an artist too?"

"I cut hair. I guess that's my art in some way."

"Oh. Cool! So, where do you do that?"

"Actually, right here on the street. I've got all my things with me in my backpack." I unzipped one side of it, exposing the tools within. "You know what I'm going to ask you now, right, Christine? Would you like me to give you a haircut?"

She giggled bashfully. "Um . . . I don't know. That would be good. It's been a while . . . I think I need a little bit of length off the bottom."

Jamie returned with some coffee. After such a long journey, it was nice to get out and meet someone like Christine. There's something grounding about a simple conversation with a stranger. It can remind you of what's important. Christine's hair was slept on. I sprayed some water and her curls came back to life. The streets got busier as lunch hour arrived. I looked around and began to recognise this area. My eyes followed the steps that we were sitting on to the end of the street. I realised that I'd spent some time here on my last trip to Melbourne.

Four years prior, I'd cut hair for a man named Luke. His charisma and kind nature had left an impression on me. Luke had been homeless for almost six months when we met. He'd wake up early each morning and spend hours making these intricate little bracelets out of materials he'd found, giving them to passersby. As I cut Luke's hair, a security guard lingered outside a nearby shop, and went out of his way to call me aside afterward. "Why are you helping this person?" he asked. "He should be working like I am working right now."

See, the thing is, Luke *had* been working. He even pointed out the high-rise building where he'd clocked in to his nine-to-five until just a few months before. He'd worked in logistics for an agency until earlier that year. His boss didn't like him much. They had an argument one day and Luke was fired. After working a casual job in a warehouse for a short time, he couldn't keep up with his rent and spent his first night sleeping out in Melbourne's CBD. However, Luke was anything but downtrodden when we met. He smiled and radiated positive energy, sharing how he'd like to move forward after this period of his life.

"I think I might move into something really positive when I start work-ing . . . social work, or something like that. It's something I've never really done, but I'd like it. Some of the most amazing things that have happened in my life have happened here . . . on the street. Like, just a couple of weeks ago, this mother and her daughter walked by and dropped a dollar, so I gave them a bracelet. They walked off, then maybe five minutes later they came back and said, 'Thank you so much for this bracelet.' They gave me hugs and it just made my day."

Aside from an aging father that Luke had an arduous relationship with, and a few cousins in New Zealand, he had little in the way of a sup-port network. Through his struggles, Luke showed resilience and made the best of his situation. I'd find out how things played out for him in the days leading up to our art exhibition.

As I finished cutting Christine's hair, she spoke of a friend who was also homeless and sitting nearby. "I'm really tight with my friend Jody, she's just up the street . . . We stay together some nights."

I put my hands into her curls and scrunched deep at the root to give some volume.

"We could walk up and find her now, if you'd like," I said.

"Oh yeah, sounds good," she replied. "I can go there with you guys."

The three of us walked up Bourke Street until we reached a jewellery store, where we found Jody sitting outside with her dog, Shadow.

"Hey, Jody!" Christine called out as we got closer.

There were layers of blankets between Jody and the concrete. Her peroxide-blonde hair hid most of her face at first, until she brushed some of it behind her ear and looked up at us.

Christine showed Jody her new haircut and introduced us.

"Very nice!" Jody said. "Where did you have it cut?"

"Right on the street. Josh is a hairdresser and Jamie is an artist. They wanted to come and meet you."

Jamie asked Jody if she would like to be in one of his paintings for the exhibition, which prompted a look of surprise.

"A painting of me?" Jody laughed. "Really? Umm . . . Okay, why not, I guess."

While I spoke with Christine, Jamie got to know Jody a little

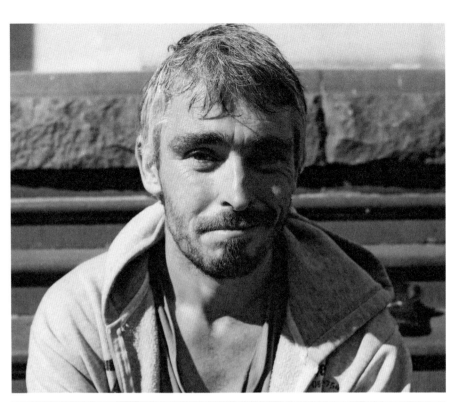
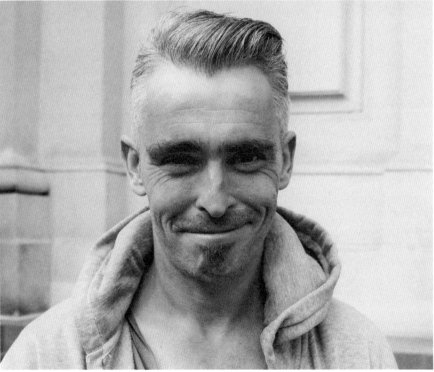

better and took her picture. That's part of his process—a black-and-white image, used later as a reference for a painting. I'm always amazed at how prolific Jamie is once he gets started. During our first exhibition in Los Angeles, his "studio" was our friend Isaac's backyard. In Melbourne, it was the balcony of Marcus's shared house—Marcus being one of HoMie's co-founders and a close friend. It was a pretty humble space. Jamie would sit there painting for two weeks straight, finishing ten portraits of people we had met.

Christine decided to head back to her spot. It was my opportunity to ask Jody if she'd like a haircut too.

"Sure!" she responded. "I've got so much though." Jody messed with her hair. "I doubt you'll be able to get through it."

Jody was right: she had absolutely tons of hair. But that gave us more time to get to know one another.

"There are some hostels we can stay in, for sure, but I won't use them because, one, they won't let the dogs in at night, and two, there are too many idiots there . . . meth heads who carry on all night, flying around, so you don't get much sleep. Sometimes you're sleeping on the floor anyway, so what's the point of me being in there? I might as well be out here. I think people assume we're all junkies and that we just want money to go and get off. They don't realise that some of us are legit and are what we say we are."

Every so often, the passing trams, constantly circulating, would ring their bells, the chimes merging with the indistinct chatter of the people around us.

Jody continued: "I find it hard to trust people . . . Some people will take anything. Two years ago, I bought a dog's bed for nearly one hundred dollars. I saved up some money, it was a really good one. I had to go to the toilet, not even five minutes, and I came back and it was gone. There were other things that they could have stolen, but they chose that. It was close to Christmas Day as well."

Jody was playful but tough at the same time. I can't imagine the difficulties of surviving on the streets as a woman. I grew up in a family of women. Thinking of one of them sleeping on the streets freaks me out. A plethora of vulnerabilities comes without a safe space to shut out the world and digest what life is throwing at you. There's no doubt that being

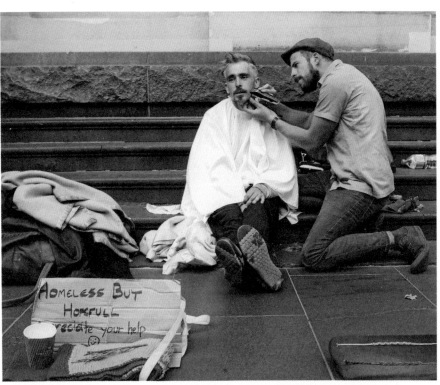

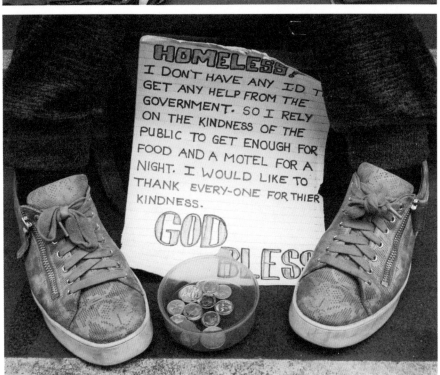

·JODY·

female brings additional challenges.

When we were finished, Jody shook her hair from side to side and swept her hands through it with new confidence.

In the week that followed, Jamie and I walked around Melbourne making friends with more people sleeping rough in the city. Jamie's paintings came to life, as did HoMie's new warehouse space, which was the location of the event. We collaborated with local artists to help amplify the voices of those we'd met and put on an evening to remember.

The week before the show, I posted a photo of Luke on Instagram, talking about the time he and I had spent on the steps near Bourke Street years before. I received a message later that evening. As my eyes scrolled through the stranger's words, I sensed what was coming.

Luke had passed away over two years ago.

I know mine and Luke's paths might never have crossed again, but I still think about that day we shared, preserved in time. Jamie decided to paint a portrait of Luke for the exhibition. We hung it high up on the wall of the gallery space, looking out across the room. Hundreds of people came that night, buying prints, T-shirts and paintings to raise money for HoMie, or the people featured within them. Jody and Christine couldn't make it, but I went back to see them once more before leaving town and printed out some photos to give to them. I walked up and down the street a few times, but couldn't find them at first. I glanced at Jody's spot one more time before leaving, and there she was, sitting herself down with Shadow at her side. It was good to see her again; I showed her Jamie's art and asked how she liked her haircut.

"Aww. You know, the amount of people who have given me compliments so far . . . People haven't been able to recognise me. It's sweet!"

Brisbane

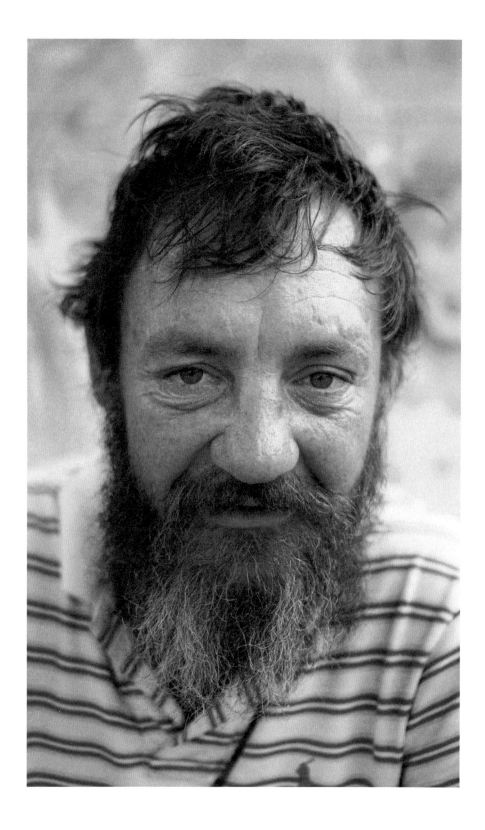

Nathan

I GOT INTO BRISBANE TWO DAYS BEFORE CHRISTMAS and travelled south to the house where I was staying for the week. My friend was away in Europe at the time, so she'd left me the keys to her place in the suburbs.

I went into Brisbane the next day. Somebody had told me about a nonprofit that runs a café and provides services to help the homeless community with temporary housing. When I arrived at their building, the gates were shut, and I couldn't see anyone inside. I looked around and noticed a man a few metres away, lying still on the pavement. A glass bottle next to him held the last drops of whatever was inside. I crossed the street to the small grocery store and bought a big bottle of water from the fridge to take back to him. I put my hand on his shoulder, gently shaking, asking if he was okay. He didn't stir. I continued for a while until a man walking by chipped in, "OI, WAKE UP!" which did the trick.

It was a moment or two before his glazed eyes connected with mine.

"You all right, mate?" I unscrewed the bottle of water and handed it to him.

"Yeah, I'm all right," he slurred. "I must have fallen asleep there for a minute."

"Yes, you were definitely asleep!" I laughed. "I wanted to check on you . . . It's pretty hot out, you should really drink some of that." I pointed to the water. "What's your name?"

"It's Nathan."

I put my bag down and leaned against the wall. The streets were pretty much deserted. It was Christmas Eve, and it felt like the city had already clocked out for the holiday.

"I tried to get somewhere to stay inside tonight, but I was too late,"

Nathan said. "It's my own fault . . . I got absolutely cooked last night, so I spent most of the morning sleeping. But the weather's good. They said it was going to rain last night, but it didn't." He took a healthy swig of water.

"Where do you stay?" I asked.

"Wherever the fuck I want, to be honest." Nathan laughed, then grew serious. "Nah, I'm lucky, really. I have a couple of friends who I can stay with here and there, not all the time . . . See, 80 per cent of people are gonna have a great day for Christmas tomorrow, and 20 per cent don't get on with their mum or their dad, or their sister, or someone, and they're gonna have a horrible day . . . It can be cruel. My mum and my dad are both dead, so I can see why people get upset. I don't though. I'm like, fuck it, I'm gonna have a good day no matter what."

I found a crate nearby for Nathan to sit on during his haircut. He thought the whole situation was hilarious. He took his seat and mimicked a client in a high-end salon.

"Could I have a cup of tea, please?" he said, summoning a posh accent.

Nathan had a good sense of humour. We laughed a lot. He'd started to sober up a little.

"There's a big difference between empathy and sympathy," he said. "Sympathy doesn't help me. When I can talk to someone who at least tries to understand me, that actually helps, you know what I mean?" Nathan's tone changed as he began reminiscing about his life before becoming homeless. "I was in the army, and I saw some things that I didn't want to see . . . It was a psychological discharge in the end. I failed to follow orders. I realised straight away that it wasn't for me, it wasn't in my nature. I couldn't do it . . . I didn't want to shoot anybody."

"Was that part of it?" I asked.

"Fucking oath it was! When you're asked to do something that just doesn't sit right with you, you either change your mind and get with that, or you back yourself . . . and I backed myself. I don't regret it. See, you've got to be able to look yourself in the mirror . . ."

My trimmers were running at full speed. I folded one of Nathan's ears down and neatened up his hairline.

"It was Dale Wimbrow who wrote that poem 'The Guy in the Glass'— you know it?" He began reciting what he could from memory. "*When you get what you want in your struggle for self, / And the world makes you King*

for a day, / Then go to the mirror and look at yourself, / And see what that guy has to say."

"I like that," I said. "There are so many lessons to take from other people who have already lived this life. That's why stories are so important, to see another perspective . . ."

"Ah, you're not gonna get all religious on me now, are you?" Nathan paused for a second, before bursting out with laughter. "Ha ha! I'm only taking the piss."

Although we were fooling around, the words of this poem obviously represented something to Nathan. Despite his current situation, perhaps it gave him the reassurance he needed to validate a ticket of doubt that appeared whenever he recalled his time spent in the army.

"It was difficult to come back to society after that . . . It's taken me years. I'm still not fucking with it." Nathan looked down at the ground.

"Did you receive any support when you were discharged?"

"Nah, they didn't provide anything, really. Once I left, that was that."

I'd finished cutting. Splinters of loose hair had stuck to the sweat on the skin of his neck. I grabbed some cleaning wipes from my bag.

"Right, then, I'll grab something to style your hair . . . Here's some mousse."

"Ah, for God's sake . . ." He started laughing in disbelief at the idea of me putting mousse in his hair. "You know I'm gonna need a fucking drink after this?! Nah, you're all right . . . I want to keep you on side, actually. You want the guy with the scissors next to your head to remain your friend."

We walked down a steep hill together until we reached a bottle shop. Nathan gunned straight for a fridge and knew exactly which brand of wine to take from the bottom shelf.

The young man at the counter recognised him as he put his things down. "How you going, Nathan?"

"Ah, not too bad, mate. Just got me a haircut!"

We found a bus stop outside and sat there for an hour. I didn't get anything, but I was happy to be Nathan's drinking buddy while he glugged away half the bottle. Then we hiked back uphill to the spot where I first found him. He plonked himself down on the ground and slumped against the wall. I wondered if Nathan was going to spend Christmas Day alone.

"You're all right, mate. I'm going to meet up with a couple of friends

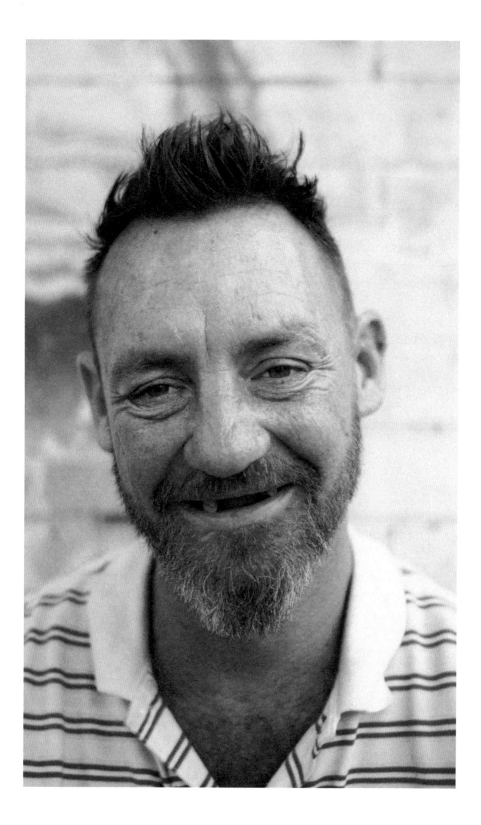

tomorrow, maybe even later this evening . . ." His words were becoming more slurred as he finished the bottle. "I'm an alcoholic, but I didn't wake up one morning and decide I wanted to be a fucking alcoholic. That's why I don't judge people. It's not logical when you can sit down and listen to a person and understand where they come from. There's an incredible amount of pain going on underneath."

That was the end of our afternoon together. I told Nathan that I had to head off.

"Well, it could have been a whole lot worse of a Christmas Eve. Hey, while you're here, you should see the Story Bridge at night. They have these fairy lights that change colour. They go from blue to purple to pink. I go and sit down there at night sometimes. It's pretty cool."

Sydney

Monty

I **NOTICED MONTY'S BARE FEET**, stretched out on the pavement in front of him, before I saw his face. They were caked in dirt, and there were no shoes in sight. He was sitting on the ground, resting against a doorway in Surry Hills, Sydney.

The store behind him looked like it had been shut for a long time. The remaining letters of a sign that read *CLOSING DOWN SALE!* peeled depressingly away from the windows inside. A backpackers' hostel stood a few buildings down the street, on the corner. Cars were roaring past.

I said hello as I approached Monty, which startled him slightly. He blinked a few times and opened his eyes wide in an attempt to recognise me.

"All right, mate," I said. "I don't know you. I just wanted to say hello."

"Oh . . ." He relaxed as he gazed at me.

Monty was striking. His appearance was dishevelled and wild, like he'd been living outside for a long time, but clearly in the city. It wasn't mud that covered his clothes; it was the grit and grime of the streets. Through his mane of matted hair, his face was kind and shined brightly.

"How's your day going?" I asked.

"Ah, yeah . . . not too bad, I suppose." Monty's thick Aussie accent came through. He spoke quietly though. "I've just been sitting here . . . watching the world go by. I sleep near the 7-Eleven back up the street there, but I decided to come sit here for a while. I don't know why . . ."

I took a seat in the doorway next to him. I couldn't see anything other than the clothes on Monty's back and a stain-covered blanket and pillow beside him. No other belongings lay in sight, which is rare for somebody who's living like this. "Do you sleep up by the 7-Eleven also?" I asked.

"Ah, sometimes. Or wherever I end up, really. I'm usually sitting out-

side the entrance there to make some money. I move around a bit, it depends on the day."

I wasn't sure if Monty wanted me there, or if he'd rather I left. He had a nonchalant way about him, making it difficult to tell.

"Is it cool if I stick around for a little while?"

"Yeah, of course. It doesn't bother me . . ."

I told him a bit about myself, and he began to open up too.

"How long have you been on the streets, Monty?"

"Ah, I've been out for a few years now. Pretty much since the last time I had myself a room. I don't know how long it was before that. It's starting to feel like a long time . . . but I keep myself to myself, mostly."

We sat quietly for a few minutes, looking out at the busy road before us. Monty was comfortable in silence, and it didn't feel one bit awkward. A part of me didn't want to burst the calm bubble that surrounded him. I thought about saying goodbye and continuing into the city, but I decided to float the idea of a haircut before doing so.

"So, you know I said I give haircuts, Monty . . ."

He turned his head toward me. "Ah, yeah . . . That would be good, actually."

There wasn't much room in the doorway, so I looked elsewhere. We went to sit in a side street, beside the hostel. I unzipped my pack and began setting up my things on the curb. I asked Monty what kind of music he liked.

"Umm . . . dunno, really. I used to listen to AC/DC back in the day, on the way to work, and that kind of thing."

I got out my phone, put on some music, and began brushing Monty's hair. I quickly realised I had more of a task ahead of me than I first anticipated. His brown-and-blonde sun-kissed locks had matted into a giant dreadlock at the back of his head. He couldn't have washed properly in months. The only option was to slowly begin cutting it out, piece by piece.

I'd be lying if I said that hair in this condition is easy to work with, but it doesn't faze me. On the streets it's rare that I've seen anything more than greasy hair, which is what you'd expect from somebody who hasn't been able to wash. If I run into skin conditions or head lice, I work carefully, buying extra products from the closest pharmacy when necessary. I make it work somehow. If I was ever unwell, I'd hope that a hospital

wouldn't turn me away on the basis of being dirty. Those obstacles are psychological. I've weaned them out of me as best I can.

Monty and I hadn't planned a style for his cut. He didn't seem to care much. He was relaxed about everything. Clumps of hair fell to the ground, until there was so much that we could hardly see the concrete. Monty mentioned that he'd once worked as a plasterer and on building sites, and as a day labourer at times. He struggled to remember much more than that.

"That was in Victoria. I used to live there. I was in Melbourne for some time as a teenager and in my twenties. I was up north, in Cairns, when I was a kid."

As I continued cutting, more dirt was revealed on Monty's scalp, from what must have been weeks of sleeping on the concrete. Although he seemed well, I felt for him. I wondered how long it had been since he last spent a night inside.

"Hmm, probably a while now. I've lived in three different houses in Sydney in the last ten years, but I've been sleeping on the streets more often than inside."

I sprayed the top of Monty's hair down with water and finished cutting. The music had stopped now. There was something nice about the last moments of the haircut. We didn't say a word. That alleyway wasn't much to look at, but it felt peaceful, with the noise of the city all around us. I kneeled in front of Monty, held his head steady with one hand and moved the blades of the trimmers over the last hairs of his beard.

As I was making the final touches, a deep, booming American accent cut through our silence. A man had stopped at the entrance to the alley, about twenty metres away, and shouted, "Barber service! Nice!" before heading into the hostel. He was wearing a bumbag and looked like he was fresh off the plane.

I gave Monty the mirror to have a look at himself.

"Yeah, it looks all right, that . . . I just thought about the last time I cut my hair. I can remember now. It was two years ago, in a public bathroom. I probably didn't do a great job then though, eh?"

We stayed there on the curb for a while, surrounded by Monty's hair and other people's cigarette butts. I handed him my camera to look through the photos I'd taken. He sat there for a few minutes scrolling through them, stopping to study his new look.

"Why don't you take a photo?" I suggested.

He put his eye to the viewfinder for a few seconds. "I don't think it's working for me," he said. I took the lens cap off and moved his finger to the right button. He pointed the camera down the street and took a photo. A childlike grin appeared.

"Well, Monty, what's next, mate?" I asked.

"Hmm . . . I guess I should be getting back up to the 7-Eleven soon." He yawned and stretched his arms behind him. "I need a coffee; it's been a couple of hours. I drink too much coffee."

"Me too. How about we go and get a coffee together?"

The sun was burning an orange hole through the thick smog that filled the sky. A blanket of smoke had drifted in from bushfires that were raging in the west and throughout Australia at the time. We walked inside the 7-Eleven together and headed for the coffee machine. Now, everybody takes their coffee differently. Mine is black, no sugar, every time. My friend Nick, who was homeless in London, used to take eight sugars—but Monty was about to top that.

"Ten sugars?!" I exclaimed, as he shook the last packet of sugar into the paper cup.

"Ah, yeah . . . you know." Monty smiled. "Sugar is sugar."

Amsterdam

Eelco

AMSTERDAM IS KNOWN FOR ALL KINDS OF THINGS. I first visited with friends when I was younger to see the coffee shops and walk through the red-light district. I went back some years later when I was in a band to play at the Melkweg, a popular music venue for touring artists on the European circuit. That time felt different. I was in town for a few days and we were shown around by some locals. It was a chance to dig a little deeper and see beyond the hedonistic exterior. I knew I'd visit Amsterdam again one day. On another trip, I'd had the chance to experience a side of the city that even most locals don't see.

It was January 2019. The man who checked me and Jamie into our room was friendly and helpful. Before he left, he asked us if we needed anything, which presented the opportunity to ask the very question that had brought us to Amsterdam.

"Hmm . . . I don't see too many homeless people around," he answered. "Maybe one or two, but I don't think there are so many here in Amsterdam, not really."

The next day, I woke up and had a conversation with my friend Eva, who lives in the city. She told me about a place we should visit called the Stoelenproject—a homeless shelter tucked away on the outskirts of the city. It helps people going through hardship and needing a floor to sleep on for the night, out of the winter cold.

Eva had a friend who volunteered there, so I asked if we could visit later that evening.

Finding the place was a challenge. The one-floor building sat beneath a highway, adjacent to a petrol station. It looked like the office of a construction site. Groups of people were lining up outside, waiting for the doors to open. We waited for a few minutes until the last person went in.

The man standing at the door stopped us and asked for our ticket. I told him our names, and he came back a few minutes later and welcomed us in.

Cigarette smoke drifted from ashtrays to the fluorescent lights on the low ceiling of the room. People were sitting on plastic chairs or on the floor. Everybody's heads sceptically turned in our direction like a scene from a Wild West movie. I scanned the room until I saw somebody whose gaze was less intimidating. I nodded at him, he nodded back, and that's how I met Eelco. I pulled up a chair next to him. I was curious to know more about the Stoelenproject, and Eelco was happy to chat. Like many Dutch people, he spoke English very well.

"If you're here in the morning, you can get a ticket to come to eat and sleep over in the night. There is only what you see in this room. People grab a space and pull out their sleeping bag. You get a good meal, and it's much better than being outside in this weather. This place is more than that though, that's why I stay here . . . I'm here because I feel like it's cosy, you know? A little bit like a home. When you're alone the whole day, it's nice to talk to somebody. But you're not always lucky if you don't get a ticket. When I'm not here I take the night bus. I'll fall asleep and then usually somebody wakes you up and says, 'Hey, where is it that you have to go?' and I don't want to say that I have no place to go. With me, you only see it when I want you to see it. I'm not proud to be homeless, or something. It's harder for me that my parents are really close by . . . I don't want to give them that stress. I don't want to show them that I'm home- less. They don't know. They think I have a little room."

Eelco's life was upside down at that moment, but he was headstrong, sure of himself.

"Things got rough for me two years ago . . . I was trying to stay afloat working in a coffee shop and paying rent, but it's expensive in this city. My life is different right now. In the evening I come here, and I go to sleep and I wake up at seven a.m. the next morning. I'm not going to work. I'm waiting . . . It's like a trial, and I'm waiting for my chance."

A man began arranging his things on the floor next to us and lay down flat before pulling his sleeping bag up over his head. I noticed some others following suit across the room. Dinner hadn't yet been served, but it was clearly the end of the day for them. The volunteers couldn't have been friendlier. I had no doubt that Jamie and I could have spent the night our-

selves had we needed to. Before saying goodbye, I asked Eelco if he'd like to meet again the next morning.

"Sure, of course. We have to leave here at seven a.m. I'll wait to see if you turn up tomorrow morning, huh?" He winked and smiled.

My alarm went off at six thirty the next morning. We took a taxi across town and arrived at the Stoelenproject just before they opened their doors. People trickled out slowly with paper cups of coffee in their hands. Eelco saw us and headed over.

"So, you guys came back, eh?" he said brightly.

We pitched up on a small set of stairs in a square overlooking a canal. It was still dark. None of us had quite woken up. Jamie and I had slept comfortably in our beds; I wondered how Eelco was feeling.

"You get used to it," he said. "I had a good sleep. You never sleep perfect, but it's a lot better than being out here." He took the last sip of his drink, and I got started on his hair. "You don't want to live here on the streets for a long time, but if you stay for a short time, I think you get to know who you really are, and who other people are . . ."

A flock of seagulls flew toward us from the canal, squawking loudly. The streetlamps flicked off as the sky grew lighter. The sun was rising above the buildings and behind us. First a dull orange, then an explosion of pink and purple that gradually crept its way across the sky. I stopped cutting as we all gazed in admiration.

"Beautiful, huh?" Eelco said. "I don't know what type of God I believe in, but I'm sure that somebody upstairs is watching me. One morning recently, I was at Schiphol Airport, cleaning myself in a bathroom over there. I walked outside afterward to smoke a cigarette, and I looked on the ground and saw some paper on the floor. I bent down to grab it and put it in my pocket and walked away. It was 250 euros. I hadn't slept for a week on the night buses. I was so tired. I just kept thinking, *Wow, this is a hotel for five nights.* I don't know . . . I think someone looking down on me had to do that."

Bicycles whizzed past more frequently as the city began to wake up. We'd all been out in the cold for a while, so we headed to a café nearby to warm up. We swapped phone numbers before saying goodbye.

Three months later, Jamie and I were on our way back to Amsterdam to put

on our next Light & Noise art show. We were driving from Paris, the site of our last event. Eelco and I had spoken on the phone a few times since that cold morning by the canal. He'd been doing relatively well and staying inside for more nights than he was out on the streets, which was good news.

It was a busy few days in the run-up to the exhibition. Jamie had made a painting of Eelco, and we had invited him to the show. We had collaborated with an art initiative in Amsterdam—Rainbow Soulclub—founded by Saskia and George, an amazing couple I'd had the pleasure of meeting on my last trip. RSC hosts weekly meetings and projects between artists and homeless people battling addiction in Amsterdam. I'd asked Eelco to come early so we could show him around the gallery space before anybody arrived.

"Do you have your things with you, Joshua?" Eelco asked, referring to my scissors and clippers. The gallery space was big, with a large glass door on one side that opened up to a balcony overlooking a small canal. We grabbed a chair out there, and Eelco sat himself down for another haircut.

"Hey, Josh, I've got some good news, brother." Eelco grinned. "You know that place I was telling you about on the phone? The place where I had the interview to apply for a room? Well, they called me back today. I picked up the key just a couple of hours ago . . ." He rustled around in his pocket, pulled out a key, and held it up. "I think this place will be really good for me, man. It's a big place, but they give you your own room, and the best part is—your independence. For the first two weeks, you get to acclimatise to the situation. You can sleep well and just get used to life again."

I was happy that we could celebrate together. People were arriving. Some of them wandered out to the balcony to say hello. Eelco really was the life and soul of the evening. As it got busier, I glanced his way and saw him entertaining a group across the room, telling them about how we'd come to meet.

Eelco's energy draws you in. I've since learned a word in Dutch that describes it perfectly—*uitstraling*. There's no direct translation to English, but it means something like "the glow that radiates from you as you enter the room."

Eelco and I have remained friends to this day. He is currently living in the same room and seems at peace there. I've gone back to Amsterdam to visit him, and he's always there for me, whenever I need someone to talk to.

Paris

Cedric, Dada & Laurent

I **WAS TURNING THE PAGES OF A COMIC BOOK**, scanning the cartoons to see if I could understand any of the French in the speech bubbles, when a plastic sleeve fell into my lap. Inside was a photo of me and Cedric, taken three months before in the exact same place we were currently sitting. I had a few hours left in Paris and was happy to be spending them with my friend, listening to music and talking. I didn't know this would be the last time I'd see him.

My view of Paris changed completely when I first saw hundreds of people living in tents beneath a highway in Porte de la Chapelle, in the north of the city. Men, women and children were freezing that winter, in the "City of Love". My prior visits had resembled the romantic postcard images projected in songs and films. When #dosomethingfornothing first began, after a few months of travelling to new cities and cutting hair on the streets of the UK, I'd decided that Paris was my next stop.

I arrived at Gare du Nord station and was eager to get on the street and talk to as many people as possible. My French is terrible, but I'd been put in touch with somebody named Laurent Demartini, an incredibly talented photographer, who helped me as a translator. We spent three days together meeting all kinds of people on the fringes of the city. I gave haircuts to anybody who was willing. I also linked up with a group called La Rue Tourne, run by my friend Agy. Their grassroots organisation brings people from all backgrounds and age-groups together to befriend those experiencing homelessness in Paris. They've helped dissolve many of the surrounding stigmas by telling stories online.

I had a day to myself and decided to walk across the city, weaving my way south through the ninth arrondissement, toward the river Seine. At a busy crossroads, I saw two men sitting across the street, in between

the pillars of an archway outside a shop. One of them held something resembling a fishing rod, with a small pot attached to the end. I laughed when I realised he was fishing for money from passersby. There was a large rucksack with badges all over it, and a cardboard sign that read *Votez pour moi cette élection*—"Vote for me this election".

When I went over to speak with them, Cedric and I clicked at once. We had the same taste in music and art, a similar sense of humour and had even lived on the same street in South London, though at different times. I'd taken a seat between the two men on the steps. Thankfully Cedric spoke English well, so he and I did most of the talking, while Dada nodded and laughed along. I apologised to Dada for my poor French.

He smiled and brushed his hand at me. "It's fine, do not worry!"

As Cedric and I discussed music, Dada would pipe up when he heard the name of a band he recognised, usually miming a song with an air guitar. He had been homeless for a while longer than Cedric; in some ways, he seemed more content. Everything was a party to him, or at least he gave that impression. I told them why I was in Paris and offered Cedric a haircut. He laughed and translated to Dada.

Dada removed his black fiddler cap and said, "Me too, me too!"

I knelt down on the street in front of Cedric and began unpacking my bag, placing everything neatly in a row on the steps.

"Wow!" Cedric exclaimed. "You have the whole salon with you! This is great. It's my lucky day, I guess." He smiled. "Make me look like . . . David Bowie."

"When was the last time you had your hair cut?" I asked.

Cedric looked out to the street and paused for a few moments. "I think it's been two years." He nodded and turned back to me. "*Oui*, it was two years ago . . . Wow."

Paris kept ticking as I snipped Cedric's hair and beard, but everything felt relaxed. I was happy to listen to Cedric's story.

"I was working at a library for a few years when I moved back to Paris. It didn't pay me very much money, but I liked having all those books around me. One day, we found out the library had to shut, so that was it. I got some jobs in cafés and bars for a while, but I could feel I was getting down at this point . . . becoming depressed in some way." Cedric's tone softened. "I do have some family, but I'm not ready to see them at the moment."

Dada was sitting a few metres away from us on the steps fishing for money again, letting out a boisterous *"Merci beaucoup!"* to anyone who dropped money into the cup. Cedric would look at me and shake his head and smile every time it happened.

"I'm happy to know Dada," he said. "He's crazy, but his heart is good. We met out here one day. He was looking over at me, so I said hello and we've been friends ever since. You need friends when you're living like this. I had a beautiful person that was looking out for me, a stepmother almost. She ran a music venue in the ninth arrondissement. It was the best place for music. Sometimes she would let me in during the day and feed me and would never ask for money. That was so kind. We would talk a lot, and she gave me hope when I was knocked down. Then one week I visited, and she wasn't there . . ." Cedric's voice quivered and broke. "Sorry." He wiped a tear from his eye. "I found out a few weeks later that she had died. I still think about her."

Cedric wore his heart on his sleeve, exposing the vulnerabilities beneath his charm. Moments later, a man exited the building to our left. He's someone I've seen again many times since that day—Frederic. He's an eccentric antique collector and music lover, an absolute wizard at restoring tube radios and amplifiers, with a huge heart for others. He'd see Cedric and Dada almost every day, and it was clear he looked out for them. When he saw that we were doing a haircut, a big smile appeared on his face. He quickly became excited, asked many questions, then snapped a few photos on his phone before running off, saying he would return soon.

I took a step back to check Cedric's hair. Only then did I realise how drastically his appearance had changed. He looked great. I polished the mirror and passed it over. Cedric lit a cigarette before turning it over to see his reflection.

"No . . ." He looked away in disbelief, before glancing at himself again and crying out, "Whaaaa! *C'est magnifique! Merci, mon pote.*"

Moments later, Frederic returned with something in his hands, a plastic sleeve with a piece of A4 paper inside, on which he'd printed some photos of us to give to Cedric.

Cutting Dada's hair was a different experience entirely, but I loved every minute of it.

"Mohican! Mohican! Punk rock!" Dada said while holding his floppy

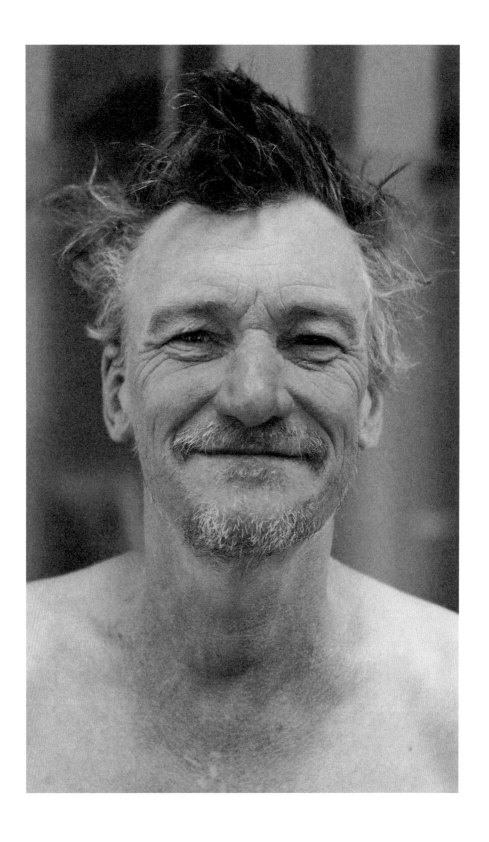

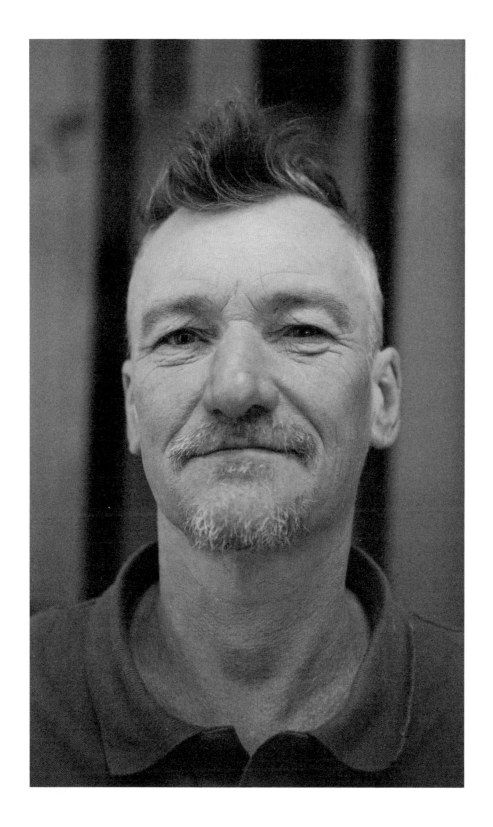

hair up with his hands to show me the style. I let him go wild with hair spray when I finished shaving the sides of his head, until he gave me two thumbs up.

The next few days came and went. I spent more time with my friend Laurent Demartini, then with La Rue Tourne, getting to know more of Paris's homeless community. I went to see Cedric and Dada once more before heading home, telling them I'd be back soon.

Three months later I was back in Paris, arriving early in the morning. I dropped off my things at a friend's place and headed out to find Cedric and Dada. Neither had a phone. I walked up the stairs to exit the metro with no clue if they'd be in the same place. When I surfaced, I looked over at the pillars and the steps where I'd met them. I couldn't see anybody at first, but I could see their belongings. I waited a few minutes, then spotted a slender figure in a brown jacket—Cedric.

I called out his name. He heard but couldn't make out who I was until he crossed the street and got closer to me. His face lit up. "Joshua! You're back!" It was so good to see him again. We hugged and spent a while there catching up.

"Where's Dada?" I asked.

"Dada went to Normandy for a month to see his sister. He goes there each summer. It's a chance for him to relax, I think."

"How about you, when do you relax?"

"Ha! Well . . . sometimes, but things haven't been as good recently."

I noticed some bruising around his eye. "What's happened?" I asked.

Cedric told me about some trouble he'd gotten into a few nights before. "The daytime is okay, but at night things can change. See that place?" He pointed to a bar across the road. "It stays open very late at the weekends, some people can get pretty aggressive . . . There was a fight that involved two men and a woman. It's probably my fault for saying something, but when I did, I got punched in the face. I'm trying to listen for places to stay, it's not easy. I hope one day soon . . . maybe it changes."

Someone else pulled up to join us—a man named Laurent (not to be confused with Laurent Demartini). He was also living on the streets in the area, also friends with Cedric and Dada. His character was, like Dada's, playful and bubbly. I could see why they all stuck together. It was time for

haircut round two. Cedric's hair and beard had grown out completely, so I cleaned him up. The difference was just as radical. When I look at photos of Cedric now, it's a stark illustration of just how hard being homeless can hit you physically, in a short space of time. He looked as though he'd aged years between May and August; Cedric was tired.

So many people knew him by name, smiling and greeting him as they walked by, or applauding the haircut. A girl named Suzy was among them. I'd receive a text from her later that year that would shake me . . .

The clouds came in just as I finished Cedric's hair. I asked Laurent if he wanted to be next, but he seemed unsure. After some back-and-forth and translation from Cedric, it became apparent that Laurent was embarrassed because he had head lice. Cedric put his arm over his friend's shoulder affectionately. I must have given hundreds of haircuts on the street for people like Laurent, and you might be surprised that I've only dealt with this issue a few times. He was the last person whose hair I was cutting that day, so I sterilised my equipment and got on with it. I wanted him to feel loved.

I packed up my things just before the heavens opened and we all scrambled for shelter. There was something therapeutic about that rain. We all shouted up to the sky in elation.

Two days later, before leaving Paris, I went back to see Cedric. We sat together looking at comics and listening to the Clash. I said goodbye and told him that I would see him next time.

Ten weeks after that day, I was in Burbank, California, and I received a message from Suzy saying that she'd found out Cedric had been taken to a hospital in the south of Paris with pneumonia. She called me again a week later and told me he had passed away. I stopped and sat down for what felt like hours . . . In the short time we got to know each other, Cedric and I had grown close. It's difficult not to go around in circles, thinking of how I could have helped more, somehow. It was all so sudden. I had projected an image of long-lasting friendship, of Cedric back on his feet, but it wasn't to be.

I knew I had to go to Paris again, if only to check in with Dada and Laurent. But I wanted to do more than that. I sent out a message to a street artist in the city. His name is Christian Guémy, or C215. I told him Cedric's story and how we'd come to know one another. Given C215's

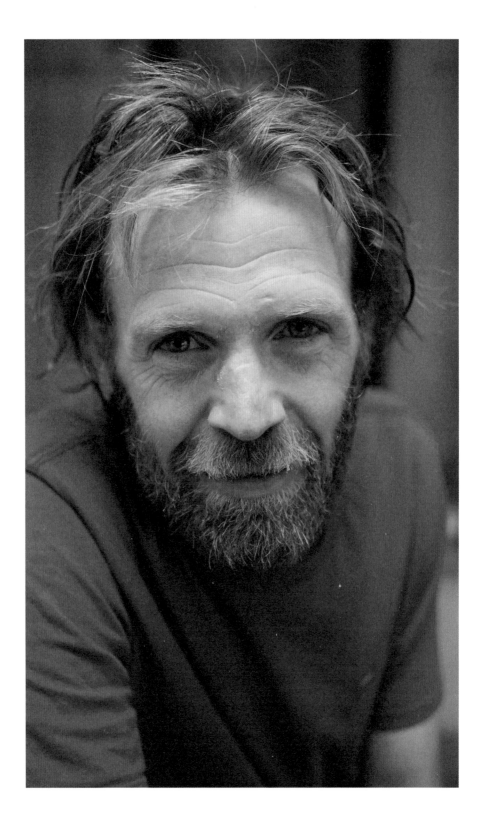

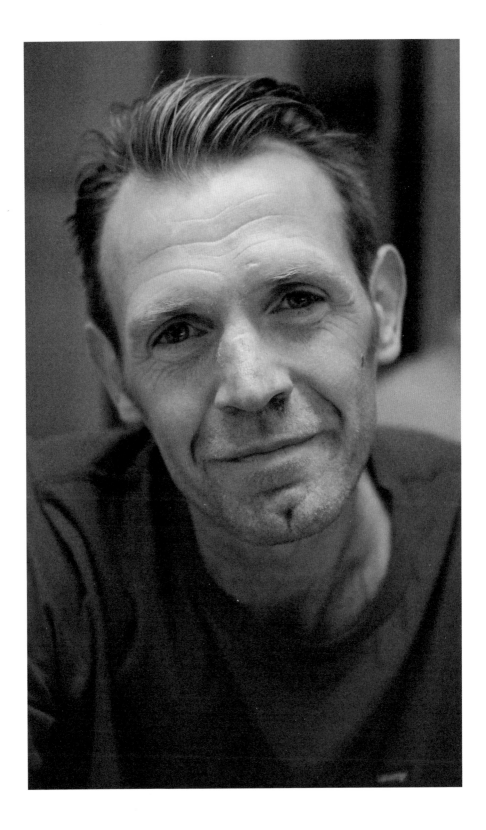

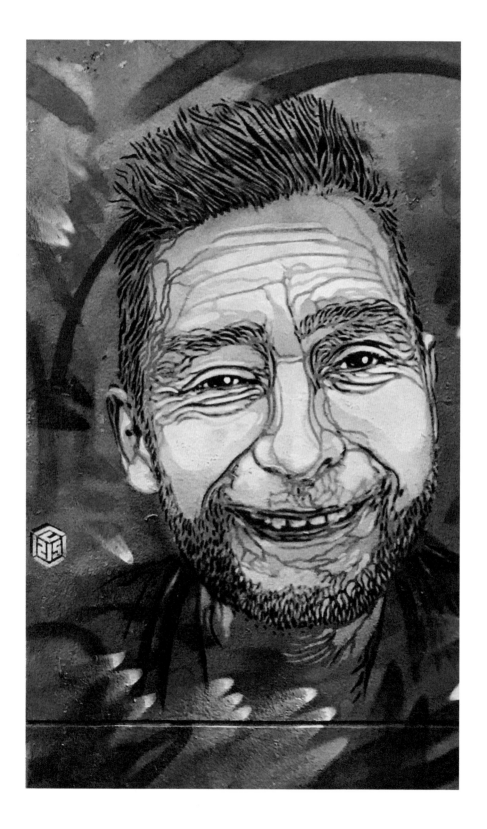

large platform, I didn't hold much hope for a response. I hit *Send* and went to make some dinner.

When I next looked at my phone, I already had a response: *Joshua. I'm happy to do this. I will pick a wall and get back to you.*

Six weeks later I was back in Paris and watching in awe as Christian sprayed a wall until Cedric's face began to appear. Flecks of bright colours danced and shined.

Whenever I travel to Paris, I visit Dada and Laurent. They're still going strong. On my last visit, Dada was making me laugh more than he ever had before. We still struggle to understand one another in words. I learn a few more in French each time, as do they in English—but of course, that's just one way of communicating.

AFTERWORD

IN THE YEARS I'VE BEEN MOVING AROUND THE STREETS of different cities giving haircuts—including the year spent creating this book—there have been times when I've ended up on the wrong side of town as it was getting dark, or found myself in situations where the energy had shifted quickly. I couldn't, however, tell you about a time when somebody did me wrong. Rude, or aggressive? Yes, but this is not exclusive to those who have no home, of course. As in any situation I try to use common sense and instinct. I respect that life on the street often comes with intense and visceral levels of stress, which breed a very different kind of social interaction than with those who live in relative comfort. It's raw and real. Every emotion is amplified when you're waking up on the concrete, and that can manifest as behaviours that may seem unrecognisable to your own life. Imagine, for a moment, the day-to-day things that may irritate you: the person who cut in line, the woman who snuck into that parking space, the man in the suit who never says thank you. We can all relate to these things. Now, picture eyes that see through you, and people who cross the street just to avoid being near you. Picture this as your actual reality. Picture this as *you*. Not *them*, or *they*. Not the person with the bottle in their hands, or the needle on the ground next to them. Not the stranger, the other, on the news through the screen of your phone, laptop or television.

Your mind and heart. Your dreams, fears and the memories that make you. We can keep telling ourselves every reason why we wouldn't end up there—in the gutter, forgotten, ignored and looked down upon by most of society—but it's a lie. We trick ourselves into believing that we're in total control of our lives, but there are so many external factors over which we are not.

Whatever your views are as to why somebody is homeless, I think we can agree that it shouldn't be normal to see thousands of people sleeping on the streets while others live in such abundance. Life brings each of us challenges and struggles of our own, which don't always allow us time to worry about anyone outside of our immediate bubble. There are days when I feel like sharing my heart, and days when I don't want to talk, or even see another person. Empathy is difficult without the dedication and time to truly listen, and that's not easy when you're running late for work, or rushing to pick up your kids from school.

If you're struggling to make ends meet and somebody holds their hand out to ask for money, I don't expect you to reach into your pocket.

So, what can we do in the small moments we have available that are usually spent making assumptions about the strangers we pass by each day? I've come to realise there's a far healthier way for me to put one foot in front of the other, and that is *acceptance*.

Acceptance that, as a human, I'm capable of good, bad and everything in between. To allow for somebody else's mistakes is to allow for my own. I acknowledge when the worst parts of me have hijacked my better self and caused me to make poor decisions, to think and act in ways that I'm not proud of. At times, my own thoughts have been powerful enough to lead me astray, down an alleyway of self-sabotage. It's dark there. You forget yourself and your true potential. Nobody in the world can drag you out unless you're willing to make those steps. We can light a match for one another though. Even the smallest moments of solidarity can be enough to create a new vision. To quote David, who you met at the beginning of the book:

A smile is the most contagious thing in the world. When you smile at someone, they can't help but smile back, and as they walk away, they think about that smile . . . and they smile themselves. Then, someone else catches that smile, and within an hour a thousand people can smile. For them five little seconds of your life, you forget it all. Every trouble and every problem. That's the truth.

While a smile does not heal trauma, or mend the heart of some-one who's been kicked around since the day they came into this world, I believe it's one of the most powerful choices we make each day. To be

aware of how we interact with those around us. To choose to give the benefit of the doubt to other people until they prove us otherwise. To form our own views, beliefs and learnings, based on our actual experiences, rather than the opinions of others rubbing off on us.

Beyond the obvious physical damage of living on the street, I believe the psychological isolation to be more detrimental. To that point, the importance of being recognised—or better, treated with dignity—cannot be overstated. How difficult is it to say hello? Who cares if it's not well received? What is the worst that could happen? A smile has led me to so many conversations that became friendships, which have taught me so much more than I can convey in these pages.

The people in this book are a handful among many thousands who wake up each day with nowhere to call home. I happened to meet them on the days I went out with my scissors and camera. If I'd gone out a day later, their faces and names might have been different, but I would have been just as curious to listen.

As for me, I'm still that same kid wanting to talk to the person next to me in class when I should have been working, but now it's become my strength.

Acknowledgements

I'm grateful to every person who has given themselves so freely to this cause. From complete strangers to close friends. From cups of coffee to places to sleep at night. To those who've been by my side to share some of these moments, to the people who've gone out of their way to help without ever having met me. I think about you all and thank you. Finally: Jasmin, for your constant love and support in abundance, always.